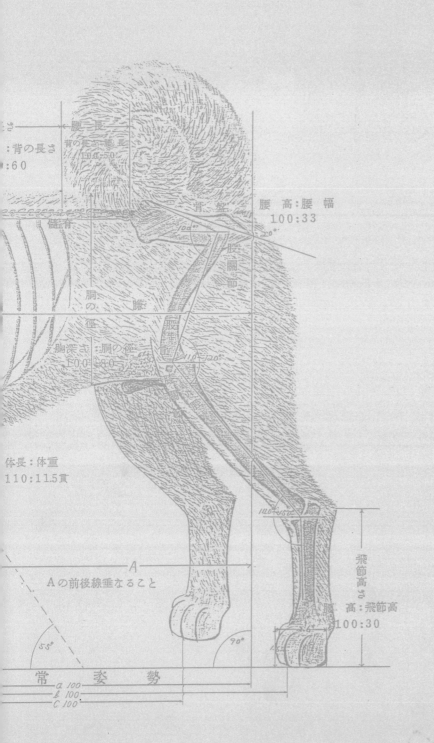

JAPANESE DOGS

JAPANESE DOGS

Akita, Shiba, and Other Breeds

Michiko Chiba
Yuichi Tanabe
Takashi Tojo
Tsutomu Muraoka

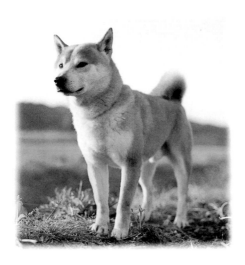

KODANSHA INTERNATIONAL
Tokyo • New York • London

Translated by Lucy North

Distributed in the United States by Kodansha America, Inc., 575 Lexington Avenue, New York, NY 10022, and in the United Kingdom and continental Europe by Kodansha Europe Ltd., 95 Aldwych, London WC2B 4JF.

Published by Kodansha International Ltd., 17–14 Otowa 1-chome, Bunkyo-ku, Tokyo 112–8652, and Kodansha America, Inc.

ISBN 4-7700-2875–X

First edition, 2003
03 04 05 06 07 08 09 10 10 9 8 7 6 5 4 3 2 1

Library of Congress Cataloging-in-Publication Data available

www.thejapanpage.com

CONTENTS

Introduction

The term Japanese dog, or Nihonken, officially refers to just six of the breeds introduced here: the Akita, Shiba, Kishu, Shikoku, Kai, and Hokkaido, since only these have been recognized to date by Nippo, the largest association in Japan dedicated to preserving and managing the native breeds. At first glance, all these dogs seem fairly similar in appearance, but a closer look shows that each breed has its own distinctive traits. There are actually three different size categories—small, medium, and large—and considerable variation in color, including red (reddish brown), black, brindle, white, and sesame (the equivalent of "salt and pepper"), physical characteristics, facial expression, and of course temperament. Dogs are known to have lived in Japan since Paleolithic times. Over the course of thousands of years, the main role that they played was as hunting dogs and guard dogs.

In total land area the Japanese archipelago is quite small, but a considerable portion of the country is covered in steep hills or mountains, which made it extremely difficult for people living in more remote communities to have much contact with anyone outside. This meant that the breeds of dog they used to help them hunt—whether for bear, wild boar, deer, or smaller game like rabbits and birds—were also kept geographically separated and there was little interbreeding, with the result that some bloodlines were preserved intact for centuries. This meant that dogs came to have certain marked features that could be identified with specific regions. Eventually, the dogs began to be called by the names of those regions. All but one of the officially recognized breeds today are named after their place of origin.

In temperament, Japanese dogs are often described as "one-person dogs" (*ikken isshu*). In extreme cases, the dogs only have eyes for their owner, to whom they are devoted; other people, even members of the owner's immediate family, are simply tolerated. The bronze statue known as "Hachiko" that stands just outside Shibuya Station in Tokyo was built to commemorate an Akita by that name who, after his master suddenly died while away at work, continued to go to the station and wait for him to come home every evening for years, until the dog's own death. And there are numerous stories of Japanese dogs who, for one reason or another, had to be given away but escaped from their new homes and found their way back to their original owners.

The two breeds that are best known outside Japan are the Akita and Shiba. Both breeds now have many dedicated fanciers around the world. After the end of the Second World War, a good number of American soldiers who had been stationed in Japan during the Occupation took Akita back with them when they returned to the States. It didn't take long for the Akita, with its composure and its proud, dignified bearing, to become well known among dog enthusiasts and breeders there. The dogs brought over at that time provided the base from which breeders in America started to develop their own Akita dogs.

At that time, just after the Second World War, most of the Akita inu to be found in Japan were rather heavier and lower-set than today's Japanese Akita, and many of them resembled the Saint Bernard in their coloring. At certain times during their history Akita had been used as fighting dogs and had been crossbred with other types of dogs to produce a stronger, more ferocious breed, and this crossbreeding had produced a strain that was much larger than the original. It was mostly dogs from this new, larger strain that were taken to the United States and used as the basis for developing the breed there. Meanwhile, breeders in Japan have

spent the decades since the war trying to produce dogs as close as possible to the earlier, original form. That is why the Japanese Akita and American Akita today look completely different. The head of the Japanese breed is more foxlike, while that of the American is more massive and bearlike. In fact, they are now treated as two quite separate breeds. In Japan, the dogs are referred to as the Akita inu, while in the United States the American variety is called the American Akita, or sometimes the Great Japanese Dog.

Nowadays, the Akita inu—the original Japanese breed—is gaining quite a following in other countries around the world, and is equally popular abroad as the American Akita. Akita inu fanciers abound, particularly in Europe and Brazil, where there are many kennel clubs and where good-quality dogs are regularly exported from Japan by Japanese breeders.

A close second in terms of popularity abroad is the Shiba, a small-sized dog that has recently become much more familiar overseas; enthusiasts have now established Shiba kennel clubs around the world. Nippo (or, officially, the Nihonken Hozonkai) has several branch chapters devoted to Shiba in the United States. The association also regularly receives requests from countries in Europe and Asia to dispatch judges for shows and other personnel to help improve the breed.

Like the Akita, the Shiba is thought to have first been brought to the United States more than half a century ago by American troops leaving Japan, but it was not until later in the twentieth century that people began to take note of what good companion dogs Shiba make. Shiba are extremely clean, they don't have that "doggy" smell, they don't bark without good reason, and once trained they are extremely obedient. The number of Shiba in the United States is now thought to run to several tens of thousands, and it looks set only to increase. With Shiba becoming so popular around the world, it seems certain that interest in the other Japanese breeds will rise as well.

The Shiba, like the other Japanese breeds, is plain-looking rather than showy. Its temperament tends to be reserved, and it is not the kind of friendly dog that will wag its tail at any approaching stranger. Yet there is something in the very plainness, the sterling simplicity of the Japanese dog, that most Japanese people find extremely affecting; this is why these breeds are always very popular in Japan. The dogs' increasing popularity overseas seems to suggest that people in other countries feel much the same way, and that there is something universally appealing about their plain, unaffected appearance.

The other four recognized breeds—the Kishu, Shikoku, Kai, and Hokkaido—were all bred as hunting dogs and used that way for centuries. The Kishu, and to a lesser extent the Hokkaido, is still used in hunting. All four of these breeds retain much more of their "primitive" quality than do the Akita and Shiba, since the Akita and Shiba have been bred for many generations for appealing looks rather than hunting ability. As a result the four other breeds are less easily socialized and tend to be harder—and some of them harder than others—to control as pets. All four are a great deal less popular and less commonly seen in Japan than Akita and Shiba. But they make up the medium size category and so are considered representative of the Japanese breeds; in fact the Shikoku and Kishu are the dogs that were used mainly as the basis for creating the Standard for the Japanese Dog.

In addition to the six recognized breeds, there are a few other breeds known as "imported breeds that were completed in Japan." These are dogs that were originally foreign breeds that were brought to Japan, improved, and then stabilized. The four best known of these are the Japanese Spitz, the Chin, the Japanese Terrier, and the Tosa Fighting Dog. Each of these breeds has its own unique and interesting history in Japan and at some point began to be exported to other countries, where they now have numerous enthusiasts and kennel clubs. But each of these dogs is relatively uncommon and not frequently seen in Japan. However, they continue to be preserved and protected as breeds in Japan through the efforts of fanciers.

European and American dog breeds continue to occupy a good deal of the spotlight in Japan. But Japanese dogs are by no means overshadowed; their popularity remains very high. If anything, it seems that their

unique qualities are now gaining renewed attention among Japanese people; and we are seeing unprecedented growth in the number of magazines devoted to Japanese breeds—magazines that apparently sell extraordinarily well.

No other country takes more interest in protecting its native breeds of dog than Japan. Preservation societies and kennel clubs abound, and the Japanese government has aided the cause of preservation and protection by giving the six breeds the official designation of Protected Species (*tennen kinenbutsu*). It would be hard to find other officially designated "cultural assets" running around so close to people and being such a natural, ordinary part of their daily lives. When most Japanese think of dogs, the first image that comes to mind is a dog with the typical prick ears and curly tail of a Japanese dog. And for everyone in Japan who loves dogs, there can be no greater joy than the fact many people in other countries have also begun to feel enthusiastically, and even passionately, about these beautiful animals.

This is the first book ever to treat all these breeds together. It is hoped that *Japanese Dogs* will serve as a source of useful, intriguing information about the background and the development of these interrelated breeds and will be of interest to enthusiasts of any of these dogs and even help to protect and improve the breeds around the world.

AKITA

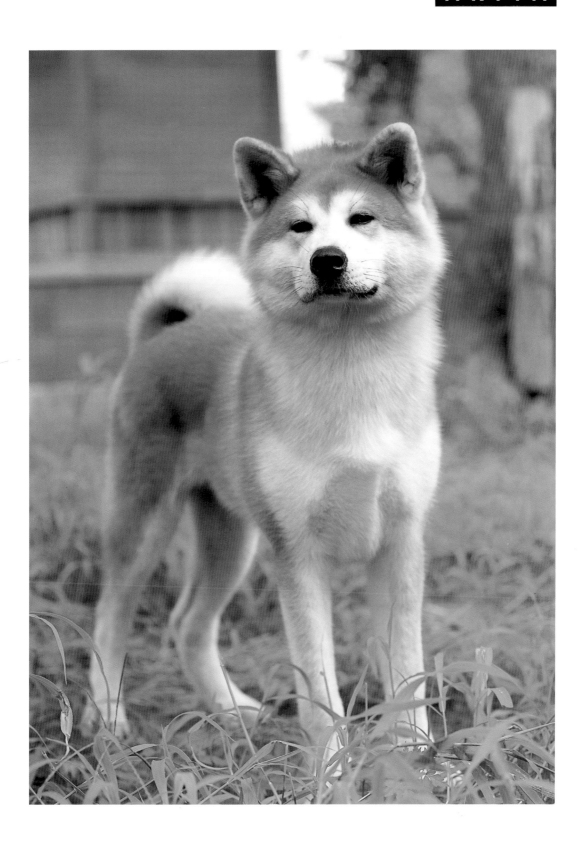

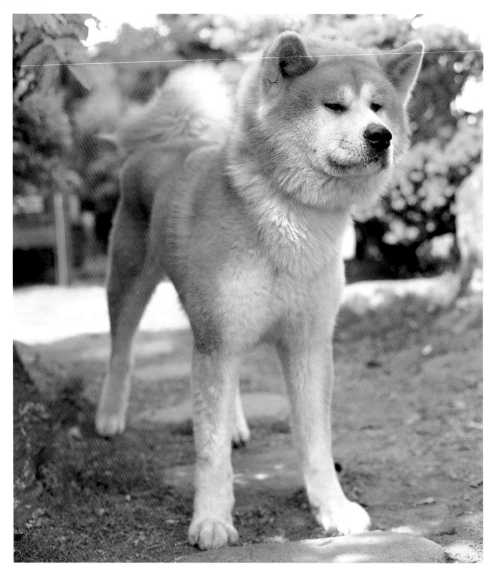

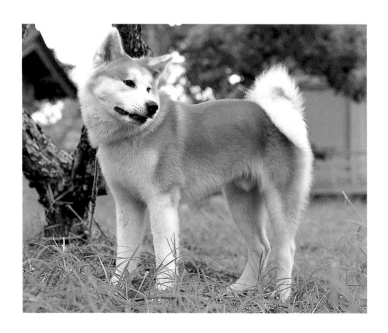

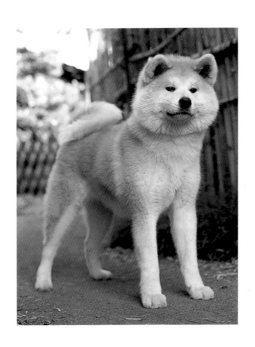

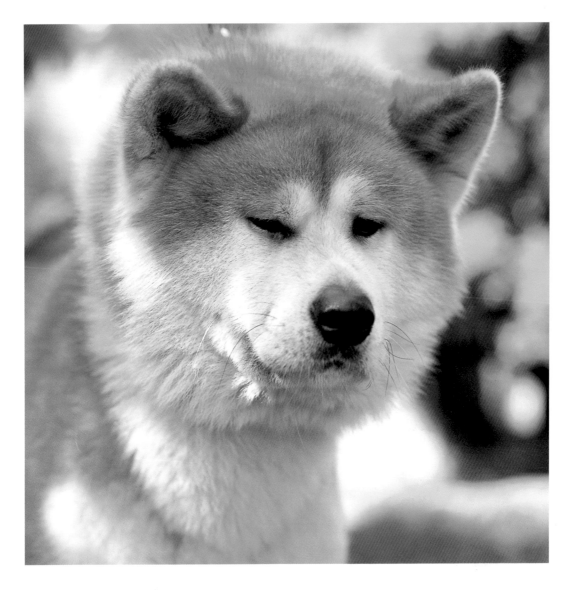

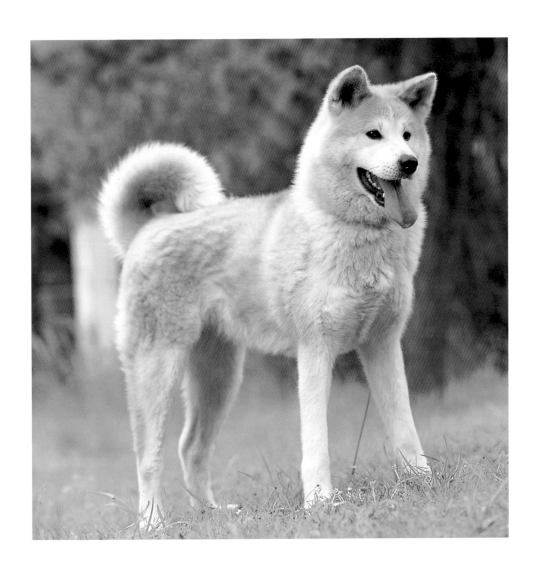

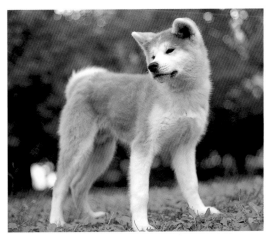

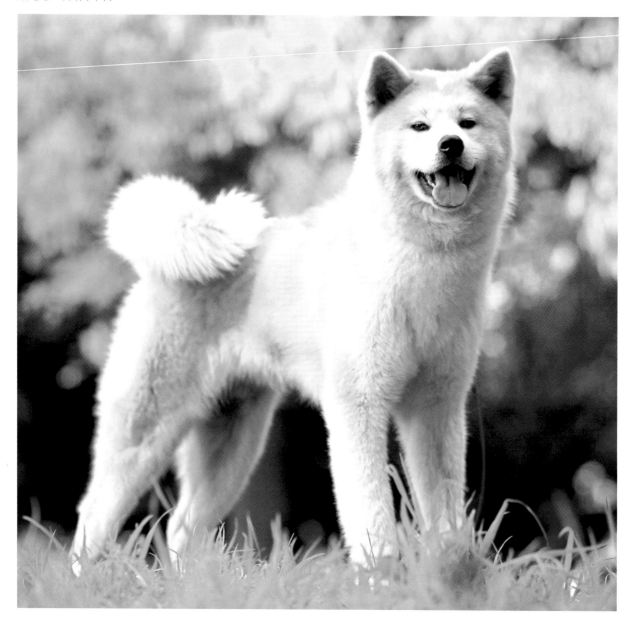

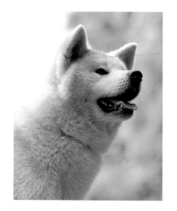

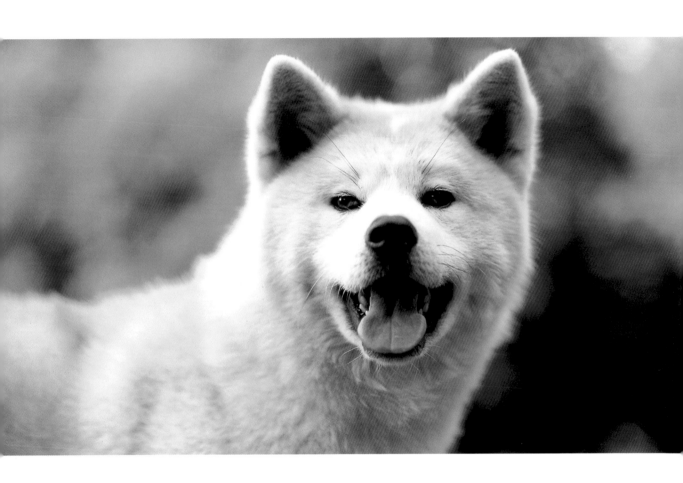

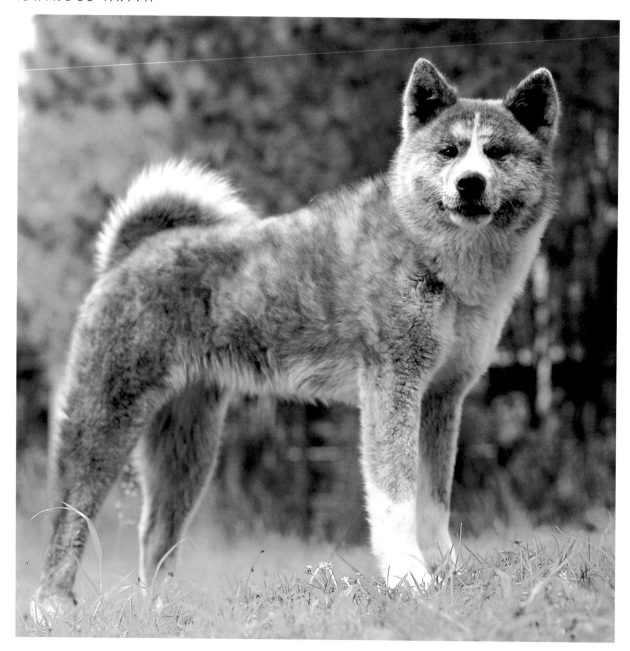

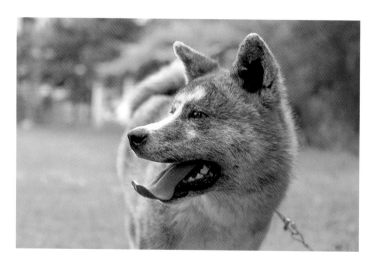

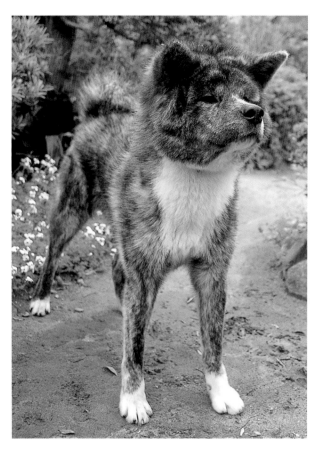
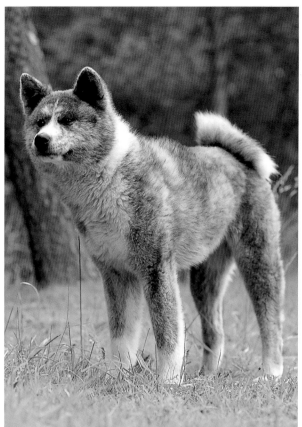

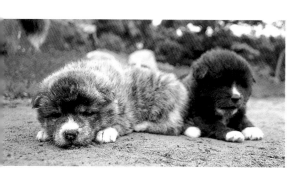

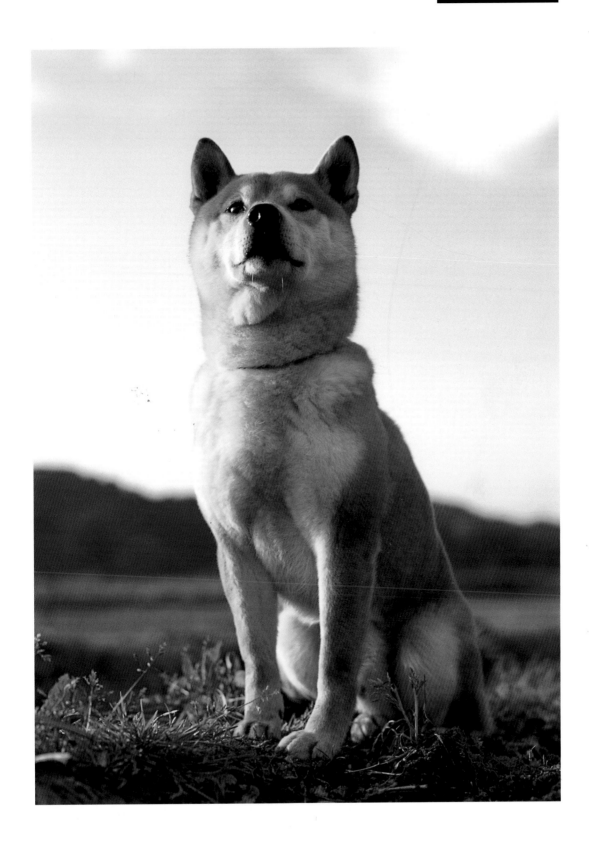

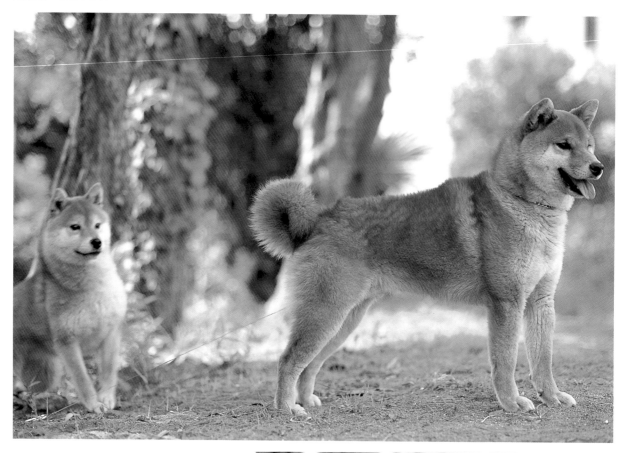

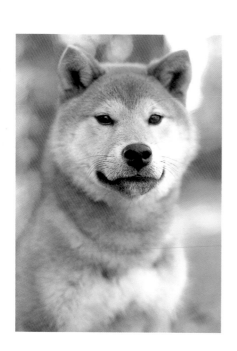

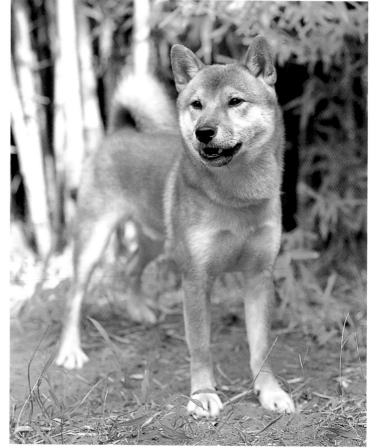

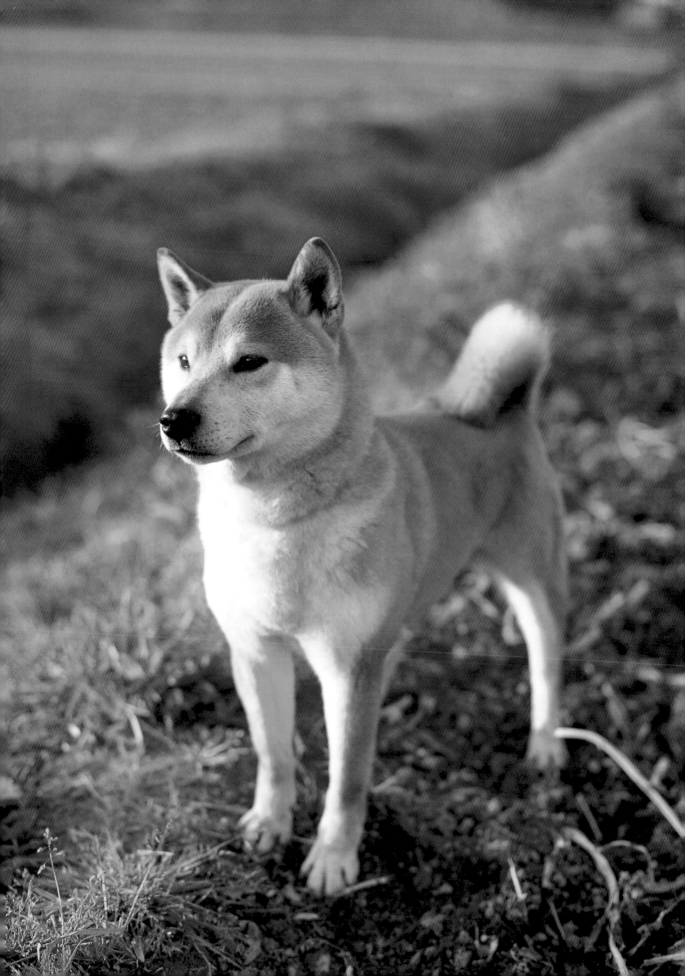

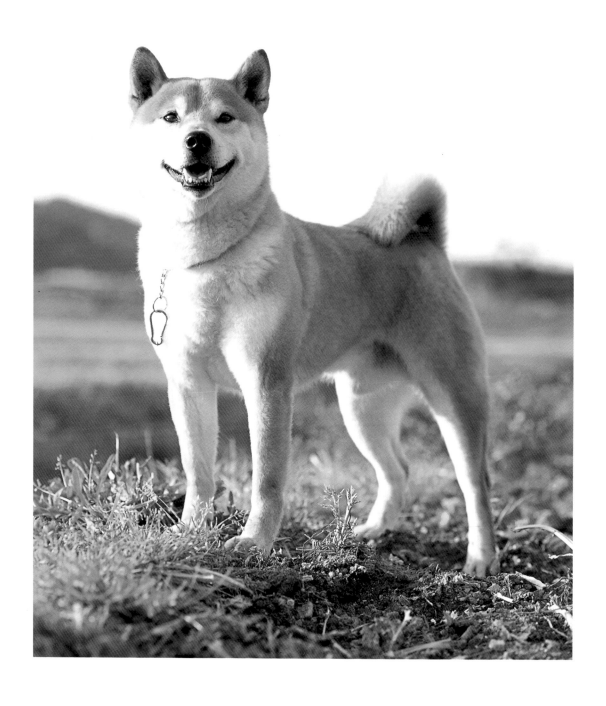

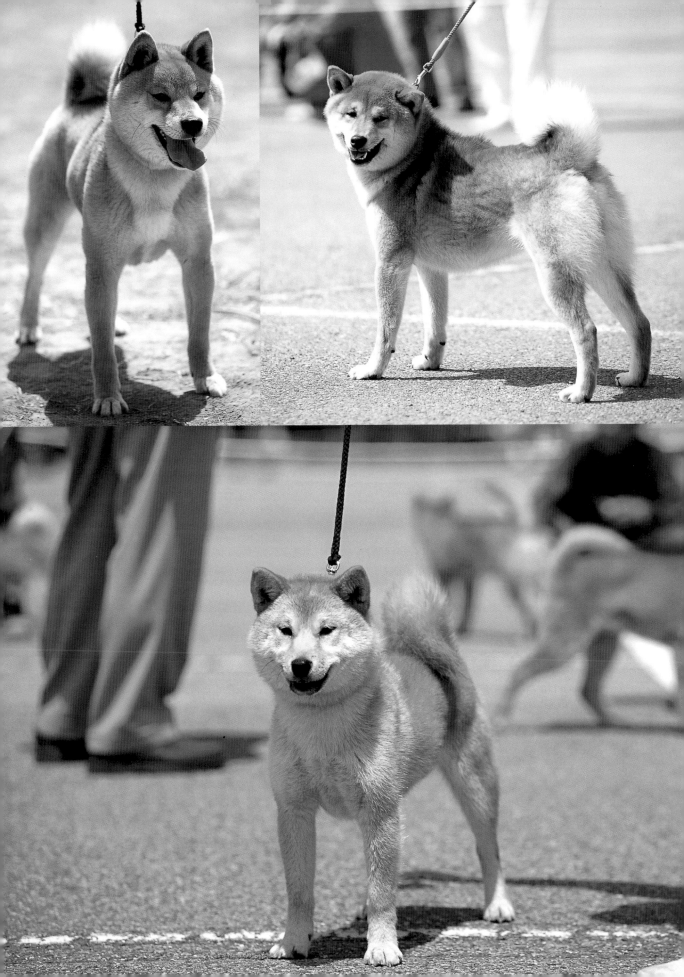

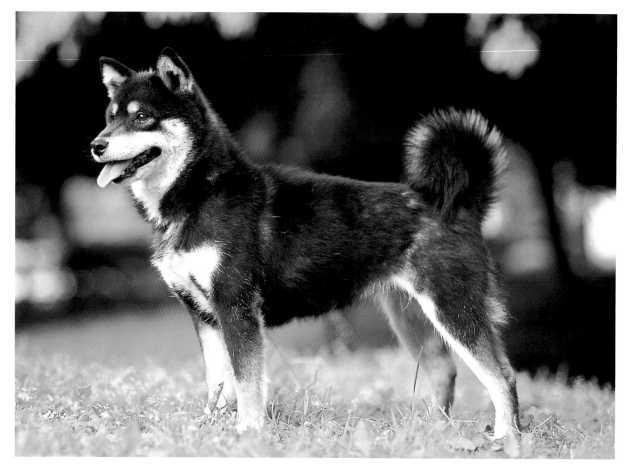

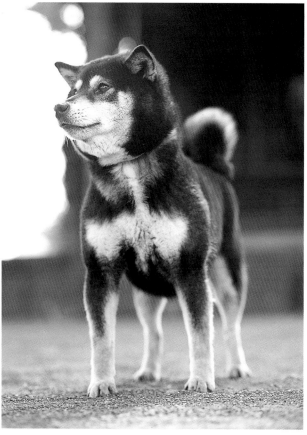

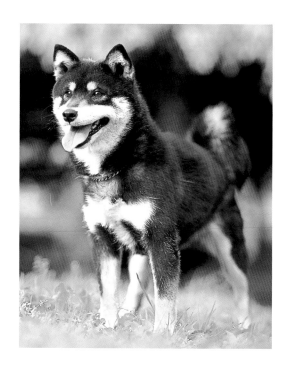

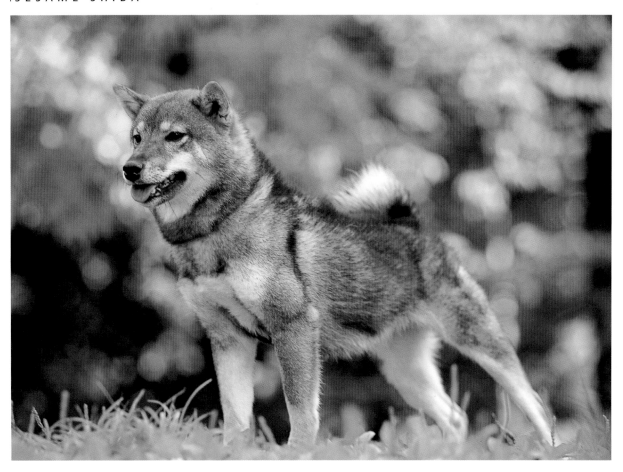

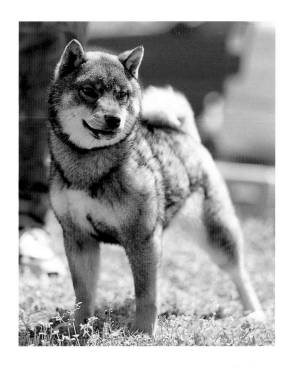

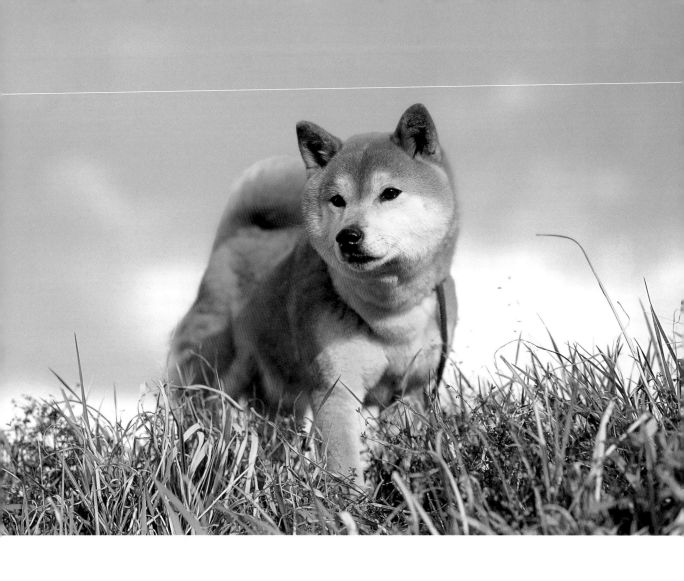

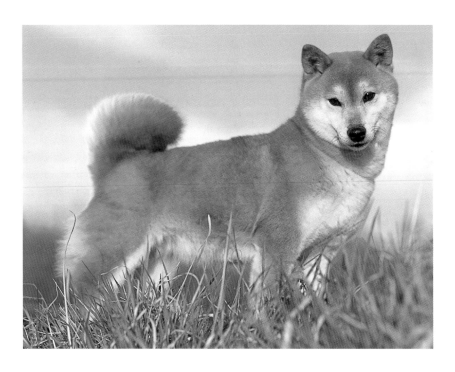

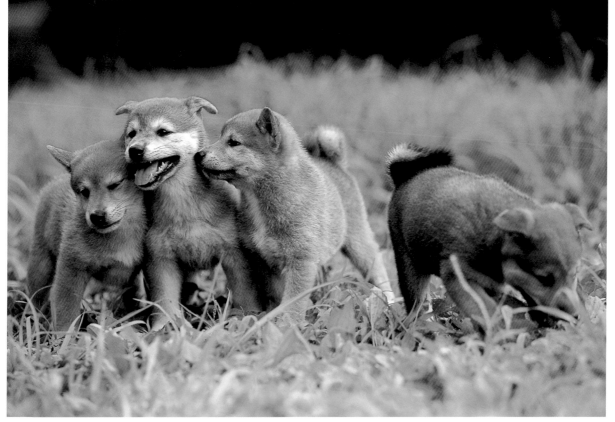

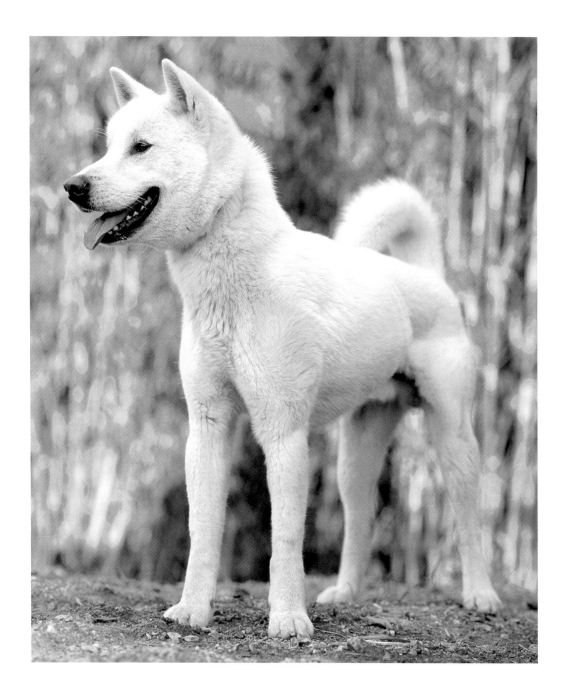

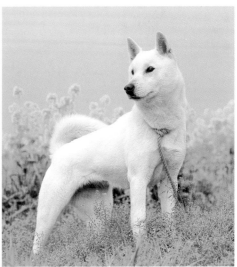

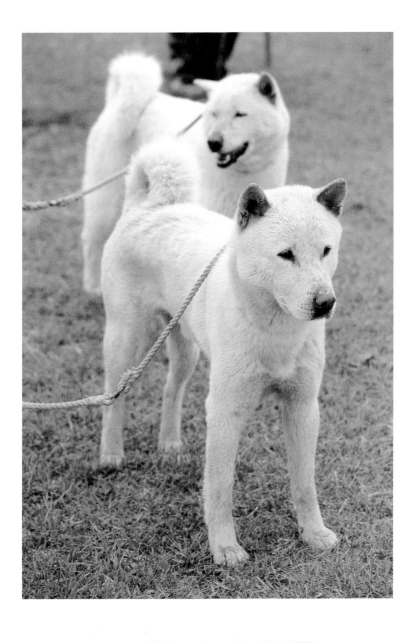

SHIKOKU

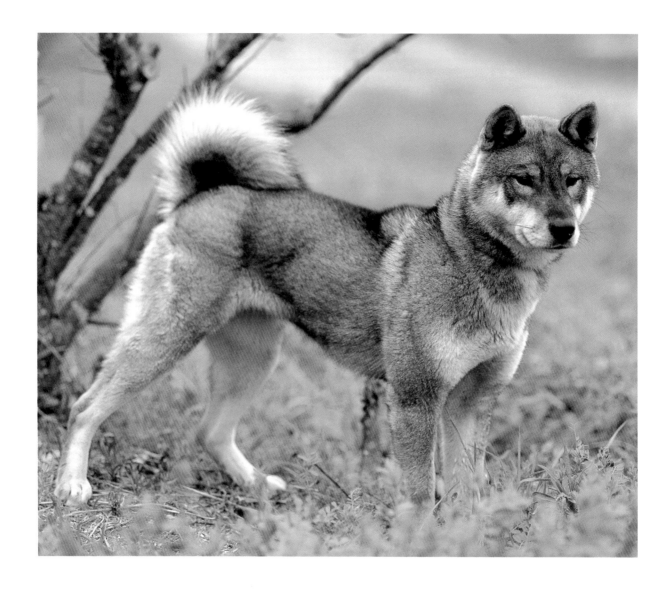

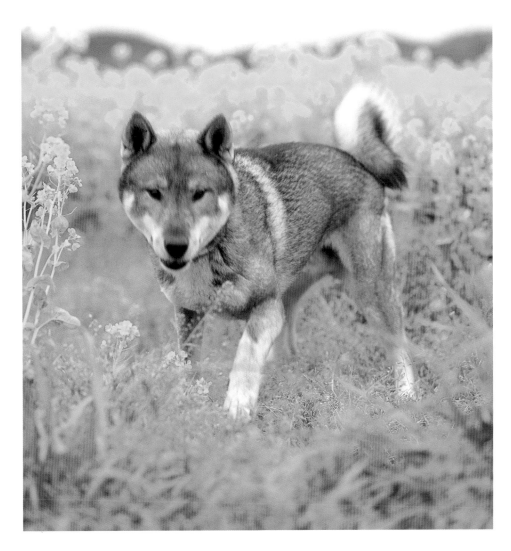

KAI

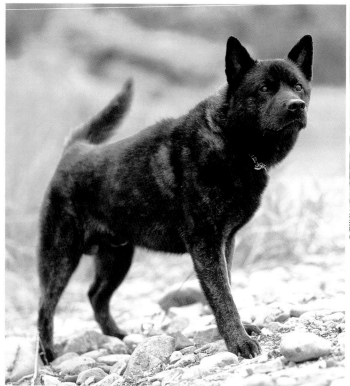
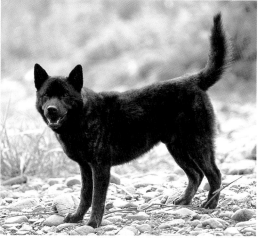
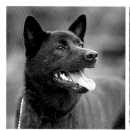
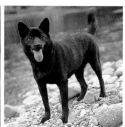

HOKKAIDO

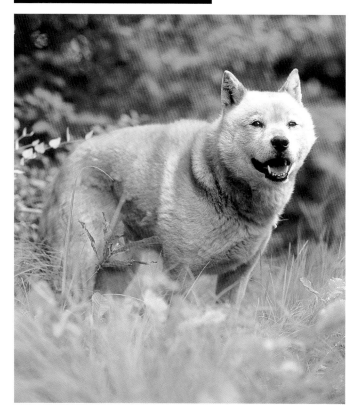
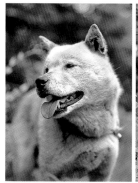
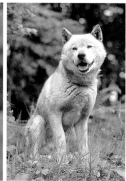
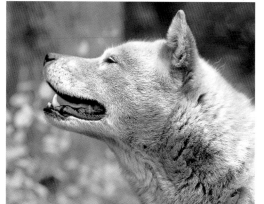

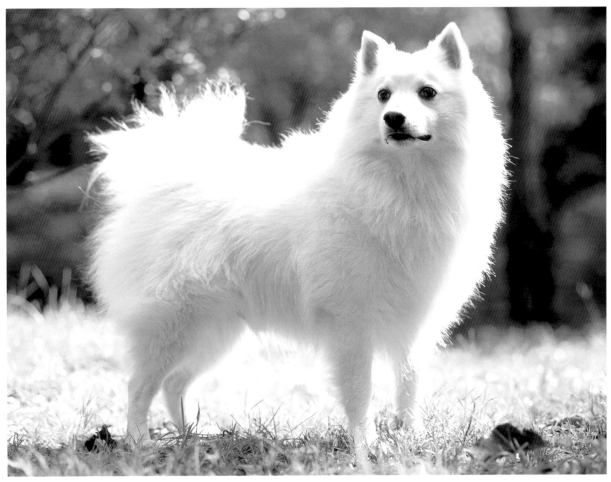

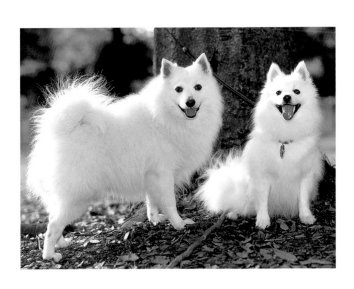

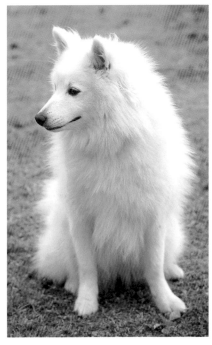

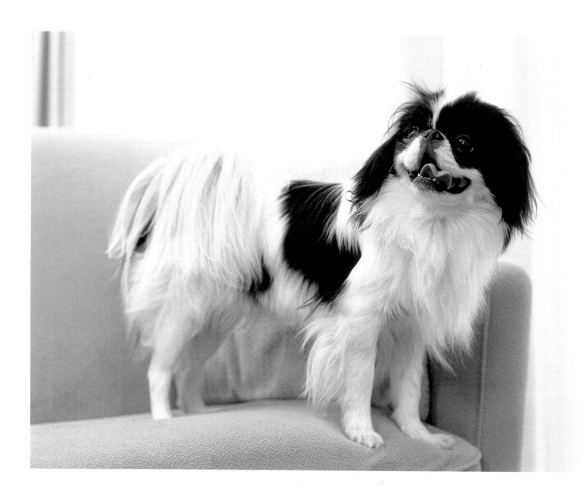

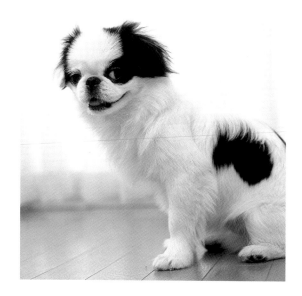

JAPANESE TERRIER

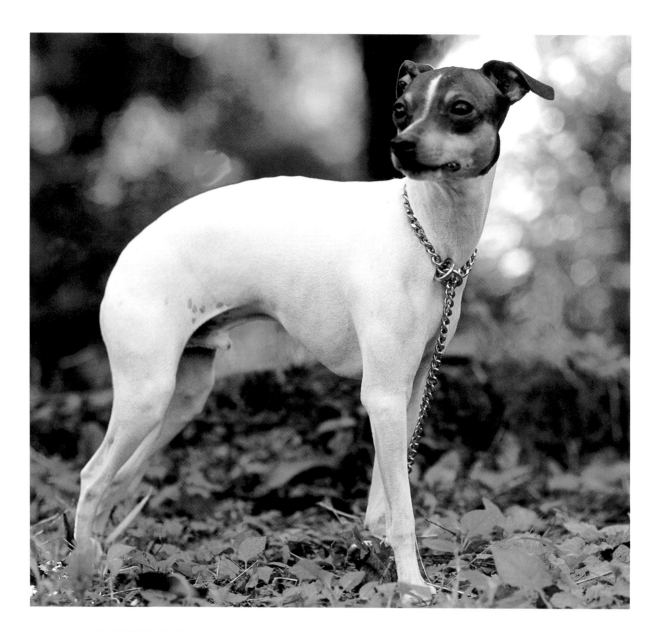

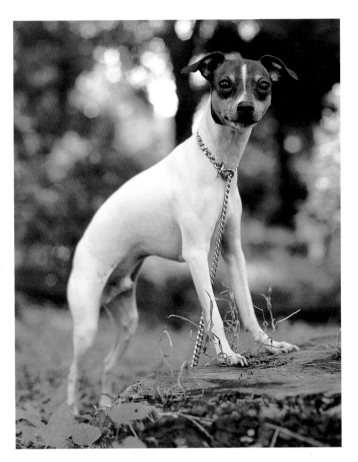
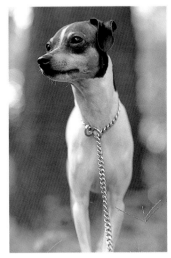
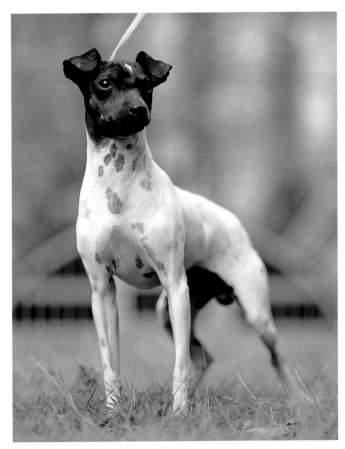

TOSA FIGHTING DOG

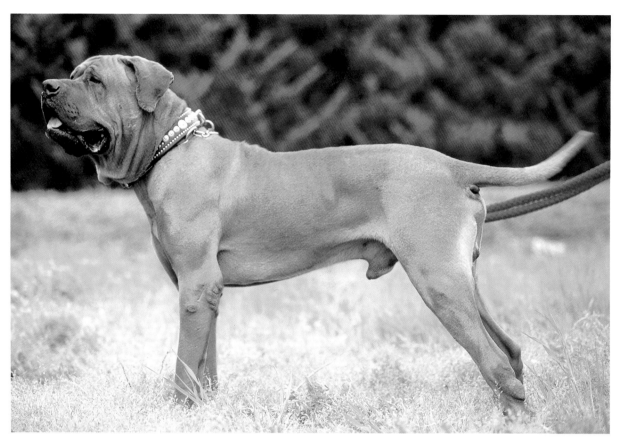

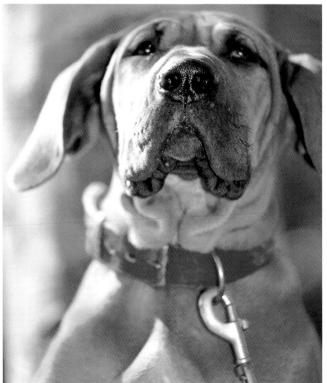

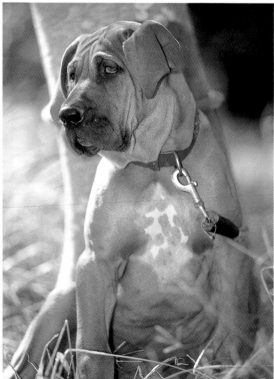

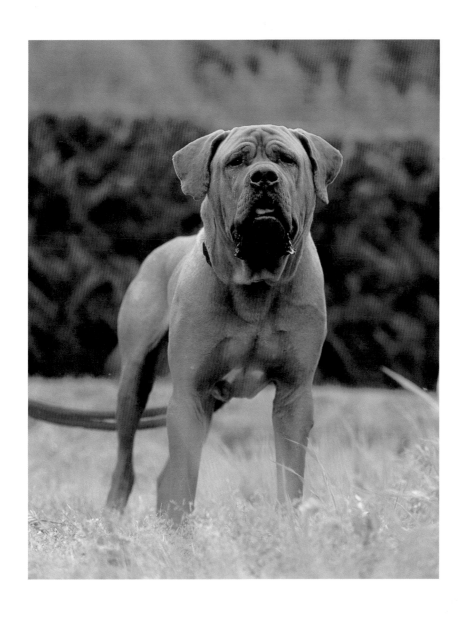

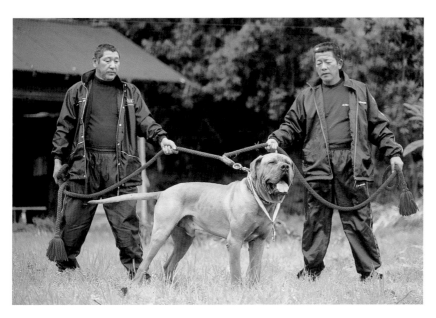

PEOPLE WITH THEIR DOGS

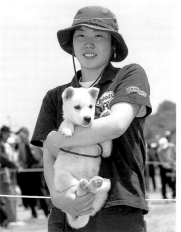

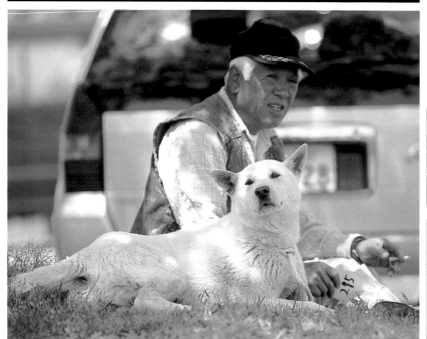

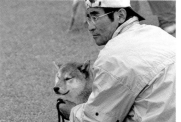

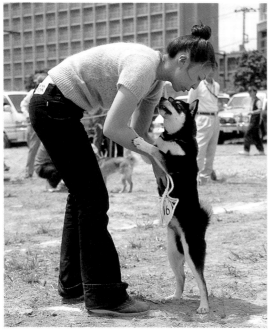

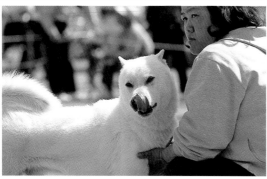

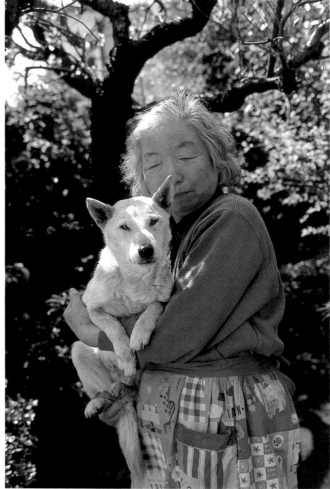

Introduction to the Breeds

OFFICIALLY RECOGNIZED BREEDS

AKITA

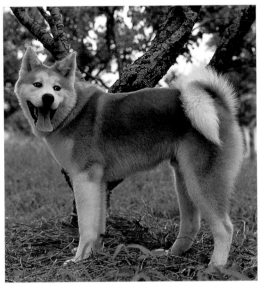

Red Akita.

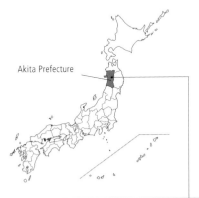

Akita Prefecture

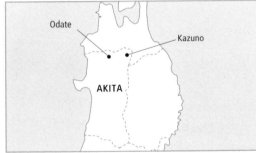

Odate

Kazuno

AKITA

The Akita originated in the area around Odate in Akita Prefecture, in the northeastern part of Japan's main island of Honshu. In the past the breed was also known by the names Odate inu and Kazuno inu, after locations in the area. Akita dogs have also long been found in the prefectures of Aomori and Iwate, which border Akita and, like it, are known for their bleak, bitterly cold winters. The Akita was developed as both a hunting dog and a guard dog.

HISTORY

The Akita's precise origins—how it first came to Japan and when—are unknown. But the relationship between its antecedents and the early human inhabitants of the region would seem to go back thousands of years. A dog's skeleton 59 centimeters (27 inches) long—much larger than any other previously identified—has been unearthed from an archaeological site in Miyagi Prefecture, southeast of Akita. Clay figures of dogs with the trademark features of contemporary Japanese breeds—the prick ears and curled tail—have also been found in ancient archaeological remains.

Originally working dogs, Akita were used singly or in pairs to hunt large game. Their owners were *matagi*, professional hunters who sold meat and fur for a living. The Akita's solid, muscular build, like its alertness and fearless temperament, is the direct result of having been reared for generations for the purpose of hunting animals such as mountain goats and bears. The Akita's role was to hold the prey at bay until it could be taken by the hunter. However, in present-day Japan it is rarely possible to see these dogs engaged in an actual hunt.

Akita are extremely territorial and possessive and have traditionally been prized not only as hunters but as guard dogs. They have played an important role in protecting family and property and in providing early warning of the approach of strangers.

It was during the feudal Edo period, from the seventeenth through the mid-nineteenth centuries, that the lords of the domain of Akita started to encourage their samurai to train and fight dogs in the hope that the men would learn from the animals' example what it meant to have true

fighting spirit. As interest in dogfighting gradually spread to the general populace, more people started to breed Akita with other varieties in an effort to produce stronger, more tenacious fighting dogs. Eventually, in the late nineteenth century, crossbreeding began to be carried out with breeds from Europe and America.

Crossbreeding with other dogs continued into the twentieth century, until eventually a group of dog enthusiasts became concerned about the Akita's restoration and preservation, fearing that if crossbreeding was allowed to continue unchecked, the true Akita would be lost altogether. In 1927, they founded the Akita Inu Preservation Society (Akita Inu Hozonkai). Not long afterward, in June 1928, amid growing interest in preserving and protecting native dogs, Nippo (the Nihonken Hozonkai) was established. In 1931, the Japanese government designated the Akita a Protected Species (*tennen kinenbutsu*), after which the breed's name was officially established as Akita.

These efforts to preserve the breed were almost undone by World War II. The years during and after the war were a difficult time for Akita, as for all dogs in Japan. Since much of the country's population was near starvation, anyone seen feeding a dog was considered a traitor. Because of their size and considerable appetite, Akita were especially hard-hit—they were killed in such large numbers that the entire breed almost died out. In the end, it is said that less than ten Akita dogs remained.

Some Akita owners during the war sent their dogs to live with large landowners, leaders of fishing villages, or others with extensive tracts of land where the animals could go unnoticed. These dogs were the ones used after World War II as the basis for the breed. From the 1950s, the members of Nippo tried to increase the number of Akita while keeping the breed quality high. Eventually two strains emerged—the Ichinoseki and the Dewa. It was dogs of the Dewa strain that were taken to the United States by American servicemen, and this strain that became the basis for the American dog. Through Nippo's efforts, the breed was finally stabilized in Japan in about 1965, on the foundation of the Ichinoseki strain. In the mid-seventies, the Akita reached a pinnacle in terms of the quality of the dogs and the number of fanciers.

The Akita has had a difficult history. But today, as a result of the efforts of the members of the Akita Inu Preservation Society to protect and propagate the Akita in a manner in keeping with the Nippo Standard and the determination of many Akita fanciers to try to attain the highest form of perfection in a large-sized dog, the Akita is now one of the two most popular breeds in Japan. An Akita in a home is seen as a symbol of health, prosperity, and good fortune.

STANDARD AND CHARACTERISTICS

It is an absolute prerequisite that Akita must have prick ears and a curled tail—features that are, incidentally, seen in very few of the large-sized breeds anywhere in the world. The Akita's frame should be large and powerful, and the build muscular.

The color of the coat should be light: the aim is to produce a coloration that matches the scenery of the Japanese countryside. To make an analogy with painting, what is desirable is the effect of watercolor, or a charcoal sketch, not an oil painting. The colors should be matte, rather than smooth or glossy.

The Akita's coat is double, consisting of the outer coat, which in Japanese is called *harige*, meaning "needle-coat," and the undercoat, known as the *watage*, or "cotton-wool coat." The outer coat should be long and coarse and stand stiffly off the body: another name for this coat is *goge*, or "hard hair." These long hairs of the outer coat help the dog endure—in fact shake off—rain and frost. The undercoat is

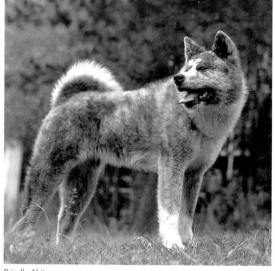

Brindle Akita.

extremely plush, and provides a thick warm covering for the skin that is quite waterproof. The Akita's coat does such a good job that even when the dog sleeps outside on the ground, it only has to get up and give a shake for the snow to slide off easily; what's more, you will often see steam rise from the spot where it has been lying. Coat color and quality are one of the most important elements of the Japanese dog.

The faces of the dog and the bitch must be clearly differentiated, with the male's suggesting potency and the female's gentleness. A desirable facial expression is one that combines calm strength, unaffected forthrightness, and a certain dignity. The color of the irises is particularly important. The eyes are one feature that gives a clear indication of a dog's character, and eyes that suggest both sternness and friendliness are generally considered ideal.

The dog's form should also convey dignity and a certain warmth and geniality. At the same time the Akita should possess enough spirit, strength of character, and courage to react aggressively if it is ever attacked. Most look very fierce and courageous and demonstrate great loyalty and powers of endurance.

It was precisely their ferocity that made them excel at bear hunting and dogfighting. Akita can sometimes show aggressive tendencies, particularly to dogs of the same sex, and they require firm training. The Akita is a working dog and will not be happy if left alone all day. It thrives on having a job to do, whether the job be obedience training, protecting the family, or hunting.

The Akita's affection and loyalty to its owner are legendary: it was an Akita dog that became the faithful companion dog of Helen Keller (who took the first Akita to the United States), and the fabled Akita named Hachiko is said to have waited at the train station for his master every evening for years after the master's death. Stories like this attest to the Akita's boundless capacity for giving affection. In fact, many pet Akita will follow an owner from room to room, while displaying an uncanny and catlike ability to avoid being underfoot.

When Akita are kenneled together with Shiba, the Shiba need to be taken for walks or given their food first and the Akita can be left till later. Shiba are very self-willed and assertive, and will whine and make a fuss otherwise. Akita, on the other hand, will wait their turn quietly.

The Akita is the slower and more reserved of the two breeds. For those who appreciate the intelligent, steady, and loyal qualities of the Akita and are willing to study the breed and get to know it well, the dog can become a precious, irreplaceable companion.

SHIBA

The Shiba is the smallest of the six officially recognized Japanese native breeds, and the only one in the small-sized category. Its perky, compact form exemplifies all the typical features of the Japanese dog, and the breed is now so popular that nearly eighty percent of all native dogs kept as pets in Japan are Shiba.

There are several theories regarding the origin of the name Shiba: that the word must derive from *shibafu*, meaning "patch of grass," since the color of its coat often resembles the tawny color of grass in winter; that it comes from the word for "brushwood," since the dogs like mountainous terrain covered with brush; and that it comes from an old local word meaning "small." Considering the far-flung localities in which these dogs were to be found—at one time there were Shinshu Shiba, Mino Shiba, and San'in Shiba, all named after their respective regions—it seems most likely that they got this name because it was thought that their coats, which are plain and have no bold markings, resemble the color of wild grasses in winter.

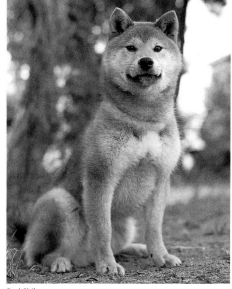
Red Shiba.

HISTORY

Skeletal remains of dogs bearing a close resemblance to today's Shiba have been unearthed in any number of archaeological sites of the Jomon period (10,000–300 B.C.). Some show clear evidence of having been buried with tremendous care, which suggests that the dogs were close to their masters and played an important role in the lives of human beings. The history of the Shiba dog may well be as long as that of the Japanese people.

A constant companion of human beings from very early times, the Shiba soon began to be kept as a hunting dog used in mountainous terrain to flush out birds and sometimes to go after small animals. However, this type of hunting was usually limited to certain areas of the country, with the result that Shiba were rarely seen anywhere else and their existence escaped widespread notice for many years.

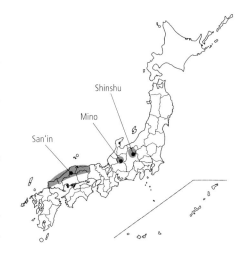

After the opening of the country to the West in 1868, numerous foreign breeds were imported into Japan for use in hunting. Some crossbreeding occurred, with the result that pure Shiba became even more difficult to find. However, from the late 1920s, informed dog enthusiasts started to take an interest in protecting and preserving the Shiba breed, and when Nippo (the Nihonken Hozonkai) was founded in 1928 the movement came into its own. With the formation of the Nippo Standard in 1934 and the official designation of the breed as a Protected Species in 1936, the dog came to be known as the small-sized Japanese Shiba.

The Second World War spelled disaster for Shiba all over Japan; their numbers dwindled and in fact the dog almost became extinct. In urban areas there were virtually no Shiba left, but fortunately the handful of dogs in outlying areas were relatively purebred. In an effort to save the breed, people resorted to interbreeding, irrespective of the different strains from which dogs had originally come. And in 1959, just when the breed was being built up again, a distemper epidemic hit various parts of the country and the Shiba population was once again decimated (seventy to eighty percent of Japanese dogs were killed in this epidemic). But breeders persisted in their efforts to first raise the numbers and then carry out better planned, more consistent breeding, mainly using the small-sized Mino Shiba of the Chubu Mountains in the prefectures of Nagano,

Yamanashi, Gifu, and Toyama, as well as the San'in Shiba from the San'in region, so that bloodlines could be stabilized. The result was the almost uniform style of Shiba dog seen throughout Japan today. Nowadays Shiba are becoming very popular as companion dogs and attracting a large number of fanciers in other countries as well.

STANDARD AND CHARACTERISTICS

The Shiba's distinctive physical characteristics are its prick ears and curled or sickle tail (*makio* and *sashio* in Japanese, respectively; also sometimes called *tachio*, or "sword tail," in an analogy to the slightly curved Japanese sword); and, in terms of temperament, alertness, intelligence, and a combination of aggressiveness and obedience. The Shiba was bred to be good at hunting all kinds of game and was used for many centuries by professional hunters, as well as by people who simply hunted as a hobby. Shiba have a natural aptitude for the solitary work of flushing out birds and small game, but they also have an amicable side that makes them able to cooperate well with other kinds of hunting dogs. However, in Japan today Shiba are no longer used in hunting.

The most remarkable thing about the Shiba dog is the strength of the bond it forms with its owner. In Japan, hunting nearly always takes place deep in the mountains, rather than on plains or moorland. With trees blocking the view on every side, it would be quite easy for a hunter and dog to lose track of each other's whereabouts. But the natural agility and effervescent energy of the Shiba, which keeps it running busily on ahead and then coming back to repeatedly confirm its master's position, make it a very effective hunting partner, and this same history makes the dog a wonderful companion or family dog.

The Shiba is a small breed but has an extremely well-balanced frame, with sex characteristics quite distinct for males and females, even in the facial area, with dogs appropriately masculine and bitches appropriately feminine. The male's face should suggest dignity and nobility, and the female's delicacy and gentleness. The bitch's head should be slighter and narrower than the dog's. In body shape, sex characteristics will present themselves in the female as a certain fullness; a pronounced fullness is especially important when the females reach two years of age and approach their prime. In males and females alike, the head should be well developed. The ears should be triangular, facing slightly inward and pointing firmly upward, with sharply defined edges.

A good way to get a natural sense of the standard for the frame of a Shiba is to look at diagrams of the

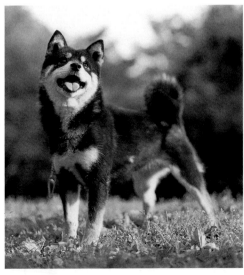

Black Shiba.

dog's anatomy and then at photos of dogs, again and again. This should make it clear that the essential factor in the overall balance of a dog's physical structure is correct angulation in each of the joints. Japan's hills and mountains have had a lot to do with the strength of the joints in the Shiba dog's legs. In Japan, many hills and mountains have inclines that are dramatically steep even when they are not particularly high, which makes stamina, more than speed, the important requirement. The Shiba's work as a hunting dog traditionally involved running uphill and downhill every day and forcing its way through heavy snowdrifts and thick undergrowth to flush out small game, which naturally fostered the development of a frame that is powerful and stands bolt upright, raring to go.

The Shiba's coat, like that of the Akita, is double. It can be red, black, sesame (either red sesame or black sesame), or white—though show judges tend not to favor white Shiba. White markings are present on the sides of the muzzle and cheeks, the underside of the jaw, chest, and stomach, and on the backs of all four legs, as well as the underside of the tail. These markings, called *urajiro*, are a distinctive and fundamental feature of the Japanese dog that may well have been deliberately cultivated, since this kind of pattern—simple and high-contrast—corresponds to a basic aesthetic preference also seen through the centuries in Japanese art. Another important feature of the Shiba's fur is that the roots are a creamy color, even along the topline and other areas where the coloration is dark. This applies even to the black Shiba, commonly referred to as Kuro Shiba.

Again like the Akita, the Shiba dog often has a black or darkish muzzle in puppyhood, known as a *kuro masuku*, or "black mask." This usually disappears when the dog is between six months and a year old (though it sometimes does not disappear in Akita). Recently more and more Akita have been presenting entire muzzle areas that are white, referred to as a "reverse mask," but this reverse mask in Shiba is not looked upon with favor by judges at shows.

The most distinctive thing about Shiba, however, is their character. They can be stubborn, but they basically love people—they are affectionate and very clever at getting their own way. They are intelligent and learn quickly, which makes them fun companions and a pleasure to train. Owners tell of instances in which a Shiba takes on the role of peacemaker in a family: if a parent scolds a child in a rough tone for some small infraction, a Shiba may jump between parent and child and start to lick both of their faces and then perhaps jump around the room in a way that makes everyone laugh and immediately dispels the tension.

Shiba are often compared with cats, and indeed they have many catlike traits. These include an independent spirit and a natural sense of entitlement. In addition Shiba are quick and agile, and their flexibility makes them resistant to injury.

Shiba get along well with the family children but are not fond of roughhousing and should not be approached suddenly by unfamiliar children. They can get along well with the family cat but tend to be aggressive toward other dogs.

Shiba are not usually used in Japan or the United States for hunting, but they still have the ability and a strong hunting drive. They love to walk through woods or fields and can capture birds or small rodents on their own. Because of their hunting instinct, they should never be allowed off-leash unless trained to the Come command (and the breed's willfulness does make it difficult to train many Shiba to this command). The dog's hunting instinct can quickly lead it far from home in pursuit of a scent. Shiba need a certain amount of exercise in order to work off stress, and training so that their energy can be properly channeled.

In many cases Shiba dogs are separated from their mothers forty-five to sixty days after birth and brought to their new owners. These first months of life are the formative period when the character of young dogs begins to emerge and take shape, and in the case of Shiba it is essential—perhaps more so than with other breeds—that dogs have frequent contact with people of different ages and sizes throughout their first year so that they can become confident and friendly adults.

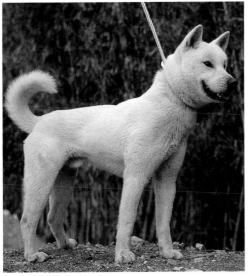

Kishu.

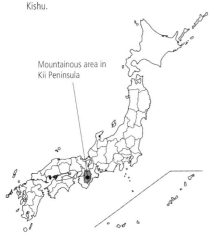

Mountainous area in Kii Peninsula

The Kishu is the most popular breed of Japanese dog in the medium-sized category, yet it is still quite rare. It is the dog most often used today in hunting in Japan.

Used since ancient times to hunt wild boar, deer, and smaller animals like rabbits, the breed originated in a mountainous area of the Kii Peninsula that straddles Mie, Wakayama, and Nara prefectures. The Nanki Kumano area in particular had many outstanding Kishu dogs, and in this part of the country they were known, after their local areas, as Kumano inu ("dogs of Kumano") and Taiji inu ("dogs of Taiji"). In the Nansei region of Mie Prefecture, another area that produced excellent Kishu, they were known as Ouchiyama inu ("dogs of Ouchiyama"). In the area from Hidaka to Arita, most Kishu dogs were white, and they were called the Hidaka-kei, or "Hidaka strain." The dog began to be called Kishu when it was designated a Protected Species in 1934.

Kishu dogs can be broadly categorized into three varieties according to the game they are trained to hunt: wild boars, deer, and rabbits. Wild boar dogs have a strong, muscular build and a fierce disposition. Deer dogs have slightly more slender bodies, since they need to be able to run very fast; they are agile and have good powers of endurance. Rabbit dogs are also used to catch birds, and they are rarer than the other two varieties, perhaps because dogs are less essential in hunting smaller types of game. Despite the differences in name and build arising from variations in the dogs' environments and the game they hunted, the dogs are all considered to have been the same breed.

Of the three varieties, the most typical of the breed is the boar dog. The indomitable spirit and ferocity of these dogs are evident from the Japanese phrase *ichiju, ikku* ("one gun, one dog"). The phrase refers to using a single Kishu to catch a boar, either by keeping the boar at bay near his lair, or sometimes setting the dog onto the boar to fight it long enough to allow the hunter to shoot the boar at extremely close range. These were the traditional hunting methods used with Kishu, and the dogs thus had to possess great spirit, courage, and physical strength. However, this method of hunting is no longer used, and now the preferred method is hunting with several dogs.

Given the Kishu's background as a hunting dog, even though it is usually calm and imperturbable, if the need arises it will quickly demonstrate its courage. It is also extremely loyal to its owner, obedient, and full of the unaffected straightforwardness typical of the Japanese breeds.

The dog can be thoughtful and silent, even cunning. Some Kishu have used as their hunting method sitting and waiting for prey to come along. Kishu are loyal to a master but not reliable with other people. The breed is perfect as a watchdog for someone living in mountainous or remote areas.

Kishu have various similarities to Shikoku. Both breeds are large medium-sized dogs and have a primitive, wolflike aspect to their character. Both breeds were developed in areas where there could be little crossbreeding and so are quite pure.

Originally there were many red or sesame Kishu, and some black or piebald ones as well. In hunting wild boar, Kishu that were sesame or red were often better able to remain unseen by their prey. But they also met more frequently with accidents, when inexperienced hunters would see their movement in the brush and mistake them for boars. White Kishu were of course easier for boars to see, but this disadvantage was offset by the fact that it was much easier for hunters to follow them. Today nearly all Kishu are white, and hardly any are red or sesame.

SHIKOKU

The Shikoku is the rarest and most primitive of the Japanese breeds. It resembles a wolf, and legend has it that the breed has some wolf blood, but this is probably not the case. This belief probably arose mainly from the dog's appearance, and from the fact that the wolf is thought to have survived longer on the island of Shikoku—the place of this dog's origin—than elsewhere in Japan.

The Shikoku does look fierce, almost wild. Its stride is smooth and swift like a wolf's, and its superb ability to leap makes it well suited to running through mountains and hills.

It was protected and preserved for its skill in hunting—mainly of wild boar—in the mountains and hills of the Shikoku Mountains in Kochi Prefecture, on Shikoku, the smallest of Japan's four main islands, located southwest of the main island of Honshu. It is also known as the Kochi inu, and was called Tosa inu in ancient times, but today it is called Shikoku to avoid confusion with another Japanese breed, the Tosa Fighting Dog. The Shikoku is thought to have been one of the dogs used as a basis for the Tosa Fighting Dog, but its physical build is completely different from that of the Tosa.

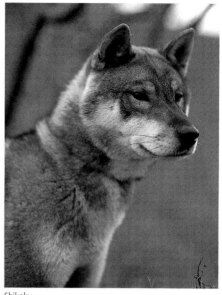

Shikoku.

In the past, Shikoku lived with *matagi*, or hunters, in parts of western and northern Shikoku. These are areas of steep mountain ranges and difficult of access, which limited interbreeding between these different locations, with the result that the breed became divided into several distinct lineages.

Shikoku dogs can first be broadly categorized into dogs from the eastern Shikoku Mountains, called the Mount Tsurugi strain, and those from the western mountains, called the Mount Ishizuchi strain. The Mount Tsurugi strain is further divided into the Tokushima (or Iya) strain, from the northwestern foot of the mountains, and the Kochi Aki strain from the southeast. The Mount Ishizuchi strain is divided into three: the Ehime-ken Shuso-gun strain in the north, the Honkawa strain in the south, and to the southwest the Hata Uwahara strain. Each of these strains originally had distinctive features in terms of physical build, which probably arose in response to the regions' different topographies.

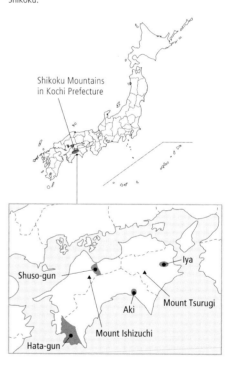

Rugged terrain made many parts of Shikoku very difficult of access, resulting in the breed's having a high degree of purity. The fact that the bloodlines of these dogs could be traced historically through generation after generation led Nippo to make the Shikoku and the Kishu, another medium-sized breed that originated in a remote area, the basis for its Standard for all the Japanese breeds.

The Shikoku is energetic and highly alert and requires hard outdoor exercise. It is capable of forming a close bond with its owner, provided that the owner is experienced at handling dogs. Its nature is to be loyal, independent, standoffish, and reserved. The dog can sometimes turn on people—even people it should know—and lunge or bite.

The coat of the Shikoku is double. The color is usually sesame, or sometimes red, and very occasionally black. The Shikoku was designated a Protected Species in 1937. It is almost completely unknown outside Japan.

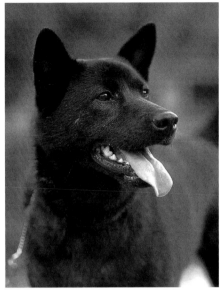

Kai.

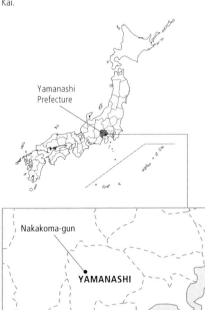

Yamanashi
Prefecture

Nakakoma-gun

YAMANASHI

Of all the different breeds of Japanese native dogs, the Kai is perhaps the most unusual-looking, and it is still quite rare in Japan. It is on the small side for a medium-sized Japanese dog, almost midway between the medium- and small-sized categories; like the Hokkaido, there is some argument about whether the Kai is too small to properly be called medium-sized. Its most distinctive feature is its brindle coat, known in Japanese as *torage*, or "tiger fur," because of which the dogs are sometimes referred to as Tora inu ("tiger dogs") or Kai tora ("Kai tigers"). The coat colors can be divided into three types according to the color and shading of the dark stripes: black brindle (*kuro tora*), red brindle (*aka tora*), and a medium brindle (*chu tora*), but black brindle is genetically dominant.

Puppies are usually born with fuzzy black coats and develop their brindle pattern with age. It can take as long as five years to come in fully, after shedding has occurred several times. The black parts of the brindle should be a soft black, and the edges of the stripes should not be sharply defined.

Kai dogs were at one time used in hunting, and they originally came from present-day Yamanashi Prefecture—formerly known as Kai no kuni—before spreading to the Southern Japan Alps, and their name comes from their place of origin. The dogs can be divided, depending on the game that they were trained to hunt, into categories of wild boar Kai and deer Kai.

Kai are thought to have originated in the village of Ashiyasu in Nakakoma-gun in Yamanashi Prefecture. This is a remote and inaccessible village made up of hunting families; its very survival depended on having fierce, intrepid dogs capable of working in small packs, and in turn the villagers were devoted to the dogs as an integral part of their lives. All these factors probably help explain the high degree of purity of the Kai and the stability of the breed. The Kai was designated a Protected Species in 1934, earlier than any other medium-sized Japanese dog.

In temperament the Kai, like most Japanese breeds, is a one-person dog: rather than becoming attached to an entire family, it is a dog that tends to be closest to one owner. It is said that if a Kai's master were ever in danger, the Kai would fight to the death, if necessary, to save him. In addition to its imposing physical form, it has a keen and watchful manner, inborn ability to work with other Kai in a pack and to guard a home, remarkable alertness, and an indomitable will. However, the Kai is a natural hunter (some Kai are still used for hunting) and should never be allowed off-leash, except in a fenced yard.

Kai need firm and loving training by a patient owner. But once a bond of trust is established, the Kai becomes the best companion dog anyone could hope for. To achieve this, the Kai should be exposed to new places and people from puppyhood well into adulthood and taken to training classes. The breed learns quickly and has good powers of judgment: some Kai have been trained as rescue dogs. The Kai may look wild, but it is said to be very good at understanding its owner's feelings.

HOKKAIDO

The medium-sized Hokkaido inu is also often referred to colloquially as the Ainu inu. The breed's ancestors are said to be the medium-sized dogs that the Ainu—an indigenous people of Japan—took with them when they moved or were pushed northward from the Tohoku region of Honshu to the island of Hokkaido about a millennium ago.

In Hokkaido, Japan's northernmost island, the summers are short and the winters are bitterly cold and snowy. Here in this land, abundant with the riches and the rigors of nature, the Hokkaido dogs lived with the Ainu people, whose lifestyle depended heavily on hunting; the dogs were used to hunt such wild animals as bears and foxes. (The word *matagi*, meaning "hunter," was incorporated into Japanese from the Ainu language.) In 1937, when they were designated a Protected Species, the dogs were officially named Hokkaido, in keeping with the custom of naming breeds after the region of their origin. Perhaps because the Ainu lived largely by hunting and fishing, the dogs seem to have been developed mainly in coastal areas and along major rivers, in areas like the Ishikari Plain and the Hidaka region.

In order to fight bears in the wild, these dogs needed not only tremendous courage but sharp senses and great vigilance. They are physically very hardy and able to withstand extreme cold, and they also have superb judgment, stamina, and endurance. All these qualities have been built up in the Hokkaido as a direct result of the extremely tough environmental conditions in which they have had to survive. Living in frigid temperatures gave these dogs an outer coat that is very thick compared to other medium-sized Japanese breeds, and a much denser undercoat. Their coat colors are highly varied, and include red, brindle, sesame, white, and very dark brown. The tongue may be blue-black, suggesting a link to the Chow Chow of China.

The Hokkaido is, like the Kai, on the small side for a medium-sized dog, and there are some who argue that it is too small for that category.

Hokkaido are wary of strangers and can react aggressively to them, but toward their owner they are extremely loyal. Given a rigorous basic training, they can be dependable partners and make very good watchdogs.

The breed is sensitive and has a fiery disposition, which means that there is always a danger of its suddenly biting someone—even, in extreme cases, the owner. The Hokkaido is so strong-willed that it can sometimes not be called off an attack, even by the owner. It needs hard regular outdoor exercise and should be raised only by people with a great deal of experience at handling dogs.

On the other hand, because of the strength of its bond with the owner, the Hokkaido can be very obedient. In World War II, Hokkaido were trained as military dogs—used, for instance, to send messages or locate enemy camps.

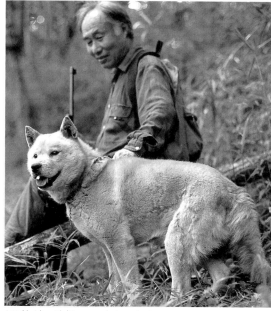

A Hokkaido with his owner during a hunt.

Ishikari Plain

Hidaka region

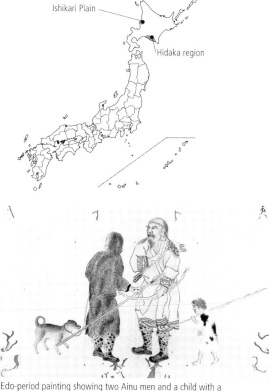

Edo-period painting showing two Ainu men and a child with a Hokkaido hunting dog.

BREEDS NOT OFFICIALLY RECOGNIZED

JAPANESE SPITZ

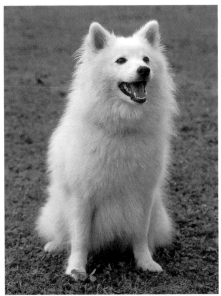

Japanese Spitz.

The intelligent, playful Japanese Spitz does not realize that it is a small dog. It is courageous and devoted to protecting home and master and alerting the family if a stranger approaches.

After the Second World War, during the late 1940s and 1950s, the Japanese Spitz was tremendously popular for a time. European and American breeds were then more fashionable than native Japanese dogs. One exception was the Japanese Spitz which, with its resemblance to Western dogs, became a status symbol. It was also considered a good watchdog because of its shrill bark.

The Japanese Spitz is believed to have derived from the white Giant Spitz, which originated in Germany and came to Japan by way of Siberia and northeastern China in about 1920. In 1925 two pairs of white Giant Spitz were imported from Canada, and in around 1936 more were imported from Canada, the United States, Australia, and China. These dogs form the basis of the Japanese Spitz seen today.

The Japanese Spitz's size makes it an ideal indoor pet, and with its small, triangular prick ears, sharp black eyes and nose, feathering tail, and perfect proportions the breed has a unique elegance and grace. The soft, thick, snow-white double coat probably makes the dog especially appealing to the Japanese. Incidentally, the word Spitz is from the German and means "sharp" or "pointed."

It was with the proliferation of apartment buildings after World War II that the distinctive bark that had once made this dog so popular became its Achilles heel, and the breed gained an unfortunate reputation as being a noisy, snappish dog. Its numbers also declined dramatically. However, the Spitz has recently begun making a comeback, thanks to the efforts of devoted fanciers who have managed to breed out the irritating aspects of its character and produce a much quieter dog. Generally a "dry" dog, stylish and refined, with brisk movements, the Japanese Spitz is exceptionally alert and attentive. In the breed Standard of the Nippon Spitz Association, it is often described as an animal that combines the qualities of small family protector and cuddly toy.

Japanese Spitzes are loyal, sturdy, bold, and high-spirited. They can be slightly willful and proud, but they are also bright and intelligent. They are effective in guarding the home, get on well with children, and make wonderful family pets. Spitzes are not hard to train, provided that the owner is always consistent. They like cold weather but are adaptable to nearly any climate. They can be raised together with other dogs, although perhaps not with the largest breeds.

The dog's profuse coat is easier to care for than it looks because rain and snow fall off or can be brushed off easily. Dogs with heavier coats may require daily brushing.

CHIN

The Chin is the first dog in Japan to be accorded international recognition as an imported breed completed in Japan. It is thought to have its ancestry in the Tibetan Spaniel, but the present-day Chin is also said to be related to other dogs like the Pekingese and the Cavalier King Charles Spaniel.

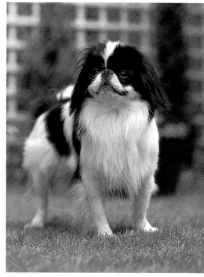

Chin.

The history of the Chin goes back to ancient times. The first Chin came to Japan in A.D.732, when the Kingdom of Silla (on the Korean peninsula) presented the Japanese Emperor Shomu with a Chin. After that, numerous Chin were imported, often by monks and official envoys who traveled to China and brought the animals back with them on their return. Over hundreds of years, the dogs were bred and reduced in size until they finally became very small lapdogs and well suited to Japanese preferences and to the relatively compact Japanese home.

From the seventeenth century on, these dogs appear in numerous paintings and writings, which suggests just how cherished they were in Japan. At the time, their status seems to have been much higher than that of other dogs, and only the samurai and nobility were permitted to keep them. The Chinese character used to write "Chin," 狆, implies an animal that is as much like a cat (猫) as like a dog, and that probably lies somewhere between (中) the two species.

Chin were also presented as gifts to visiting diplomatic officials and luminaries from other countries. Official records show that in 1613, Englishman Captain Searles was given a Chin dog. In 1853, Commodore Perry was presented with several Chin dogs, two of which he later gave Queen Victoria. In 1880, a Chin dog was sent to Kaiserin Auguste Victoria (the wife of Kaiser Wilhelm II) of Germany. More and more Chin dogs were taken abroad, so that people gradually became familiar with the Japanese Chin.

Efforts at improving the breed began in earnest in the mid-1920s and continued for several years. During the first half of the twentieth century, the Chin was divided into several types—the Kobe Chin, a large-sized dog with a very feathery tail; the medium-sized Yamato Chin with tan patches; and the small Edo Chin. However, the present-day Chin was created from a blend of all the animals that were left after the Second World War.

The Chin is a dainty, aristocratic dog. Its outline is nearly square. In terms of coat color there are two possibilities, black-and-white or red-and-white; the black-and-white is more common. The eyes are set widely apart, round, black and lustrous. White areas in the corners of the eyes give the Chin a look of perpetual astonishment. The ears are feathered and hanging. The coat is single, abundant, and silky. The tail forms a plume. The coat needs be brushed and combed often. The dog's large eyes should be examined regularly and gently cleansed if needed.

As a pet it is quiet and intelligent, extremely obedient, affectionate, and devoted to its master and family. It is bright, inquisitive, and alert without being aggressive. The Chin is good with other dogs, and even as an older dog never loses its cute looks or its amiable charm.

The Chin is often described as being catlike, and in fact Chin do well with other pets such as cats. They are great climbers and jumpers, and they can often be found in the most unlikely of spots. They also have an innate sense of self-esteem and dignity. They become depressed if neglected or treated indifferently. They seem to view themselves as equal to their owners, and to make definite choices about who they do or do not like. At the same time they are very dependent and require a lot of affection. They should be owned only by someone who is gentle and is willing to cuddle often.

Chin fit well into apartment life and need minimum exercise. They should be closely supervised when outdoors because they are more fragile than many larger dogs. The dogs are friendly with all family members but will usually prefer one person in particular. Chin can get along with children, but children need to be taught to handle them gently.

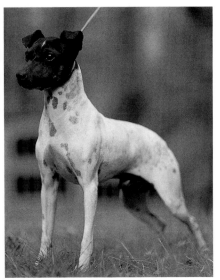

Japanese Terrier.

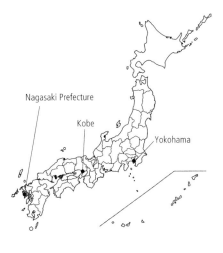

Nagasaki Prefecture

Kobe

Yokohama

Although it is a native breed, the Japanese Terrier is very rare even in Japan. A small dog, it is commonly thought to have been developed with the Smooth Fox Terrier as the base and incorporated such dogs as the Toy Manchester Terrier and the Italian Greyhound through crossbreeding of these dogs with small native Japanese dogs (about whom little is known today). In fact, however, there are also several other theories about the dog's origin—involving areas as far apart as Nagasaki Prefecture (in Kyushu), Kobe, and Yokohama—and no one is certain of the dog's history.

If the Japanese Terrier did originate on the island of Kyushu, the place where it first became fixed as a breed, after years of improvement, was probably the Kansai region. At one time this dog was known by various names: the Mikado Terrier, Japanese Fox Terrier, Kobe Terrier, and Short Haired Terrier. Planned breeding for improvement started being carried out in around 1900, and completion came in 1930. With the founding of the Japan Terrier Club, a Standard for the breed was established.

Its coloring is the Japanese Terrier's most distinctive feature: the entire facial area is black, like a mask, but the body is white. In Japanese this is called *menkaburi donuke*, or "face masked, body exposed." The coat coloration must include three colors—black, brown, and white. A black saddle on the back is known as *hinomaru* ("rising sun," a reference to the Japanese flag), while a black patch at the base of the tail is called *odome* ("tail stop") and makes a dog especially prized. The smaller the dog, the more beautiful it is considered. The tail is docked during puppyhood and is carried high.

A distinguishing feature of the breed is that it has either a "bamboo-grass" (*sasa*) ear or a rose ear. The bamboo-grass ear folds over in a V shape, while the rose ear bends over and forward slightly, so that from the side you can just see inside the ear; the rose ear is often wider. The dog's outline is square in appearance, while the fur is extremely short, only a few millimeters long at most, and smooth and glossy, with a velvety texture. While this makes grooming an extremely simple task, it also makes the dogs susceptible to cold. The dog does not need a great deal of exercise.

It is thought that there are now between one thousand and fifteen hundred Japanese terriers in Japan, and only about two hundred in other countries.

The Japanese Terrier was bred to be a companion dog, and it is sensitive and very alert. It is also wary and cautious, and a bit shy. It resents a strong hand or too much scolding. It can take a little time to get used to people other than its master. Despite its small size, it makes an excellent guard dog (even when apparently fast asleep it will hear the slightest sound), and it is also charming as a pet. It is best raised apart from more rambunctious breeds.

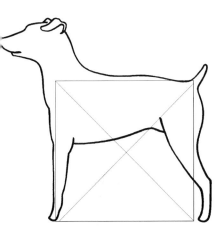

The outline of the dog's body is square.

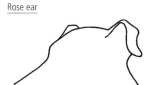

Rose ear

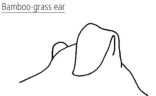

Bamboo-grass ear

The two types of Japanese Terrier ear.

TOSA FIGHTING DOG

The Tosa Fighting Dog (Tosa token)—also known as the Tosa inu and the Tosa Mastiff—has a history that goes back to the Edo period (1603–1867). The seeds of the dog's development were planted when the lord of Tosa domain (present-day Kochi Prefecture), Yamanouchi Soro, started encouraging his samurai retainers to take up dogfighting in order to boost their martial spirit.

At first the samurai used Shikoku dogs, which were native to the region, but from the latter part of the eighteenth century these dogs were crossbred with dogs brought from Holland and Spain such as the Mastiff, Bulldog, Bull Terrier, Great Dane, and German Short-Haired Pointer in an effort to improve the breed. In the second half of the nineteenth century breeders set out to produce a stronger, more tenacious fighting dog capable of winning against the large Occidental breeds; with the addition of numerous Western breeds the dog eventually took on an appearance completely different from that of the Shikoku. The fact that it has inherited much from the lineage of the Mastiff makes it closely resemble that breed, which is one reason why it is often called the Japanese Mastiff. This dog is a massive, large-boned animal with a powerful, athletic body and with dropped ears and a heavy dewlap. The body is slightly longer than it is tall. Its tail, which is usually docked, is thick and hangs down, and its coat is short and very dense. There are three colors—red, fawn, and dull black—and red is considered ideal. Red dogs are sometimes referred to as *aka ichimai* ("wrapped in a sheet of red"). The dog is greatly respected, but rarely seen, in its home country.

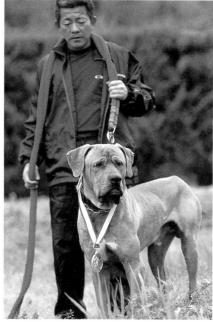

Tosa Fighting Dog.

The life of a Tosa Fighting Dog is comparable in many way to that of the sumo wrestler. They fight in a special arena, or *dohyo*, and are divided into four weight classes. Within each class dogs are assigned, according to their fighting ability, ranks whose names are borrowed from the traditional sport: *yokozuna* (grand champion), *ozeki* (champion), *sekiwake* (top salaried wrestler), *komusubi* (salaried wrestler), *maegashira* (salaried wrestler, lower rank), and *makushita* (unranked and unsalaried wrestler). The *yokozuna* even parade before each tournament in lavishly decorated ceremonial aprons (*keshomawashi*). The dogs fight in a way that avoids causing severe injury to the opponent, with the first dog who manages to pin the other to the ground declared the winner. In addition, a dog is defeated if it whines, shrieks, groans, tries to run away, or becomes too tired to fight. Breeders are very careful not to let the dogs injure one another. If the dogs begin to bite each other, the owner will flick a cigarette lighter right by their heads; this surprises them enough so that they release their grip and can then be pulled apart.

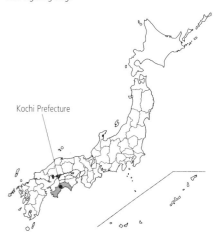

Kochi Prefecture

This dog's character is marked by a mixture of fearlessness, patience, and composure. Bred to fight silently, it rarely barks. The Tosa can be affectionate toward people it knows. However, it is a breed that was bred first and foremost for fighting. Proper supervision and due care should be exercised at all times in handling a Tosa. If it is kept simply as a pet without appreciation of its history or temperament, or is not given proper training, there is a risk that its inbred fighting spirit and aggressiveness will come to the fore. It is a good idea not to approach a strange Tosa and not to leave children with the dog unsupervised. A consistent education that starts in early puppyhood and combines strict training with love and perseverance is required for dogs of this breed.

In Japan the dog is still raised for fighting, and Tosa are not often entered in shows. The world of Tosa breeding and fighting in Japan is tightly knit and even rather secretive, and setting out to buy a Tosa of one's own can be a very difficult undertaking. It should be noted too that in the United Kingdom there is actually a ban against owning a Japanese Tosa.

STANDARD HEIGHT AND WEIGHT OF JAPANESE DOGS

OFFICIALLY RECOGNIZED BREEDS

■ Small breeds (Shiba)

Standard Height Male: 39.5 cm ($15\frac{1}{2}$ in.) (Range: 38–41 cm / 15–$16\frac{1}{8}$ in.)

Female: 36.5 cm ($14\frac{3}{8}$ in.) (Range: 35–38 cm / $13\frac{3}{4}$–15 in.)

Standard Weight Male: 9–11 kg ($19\frac{3}{4}$–$24\frac{1}{4}$ lbs.)

Female: 7–9 kg ($15\frac{1}{2}$–$19\frac{3}{4}$ lbs.)

■ Medium-sized breeds (Kishu, Shikoku, Hokkaido, Kai)*

Standard Height Male: 52 cm ($20\frac{1}{2}$ in.) (Range: 40–55 cm / $15\frac{3}{4}$–$21\frac{5}{8}$ in.)

Female: 49 cm ($19\frac{1}{4}$ in.) (Range: 46–52 cm / $18\frac{1}{8}$–$20\frac{1}{2}$ in.)

Standard Weight Male: 17–23 kg ($37\frac{1}{2}$–$50\frac{5}{8}$ lbs.)

Female: 15–18 kg (33–$39\frac{5}{8}$ lbs.)

■ Large-sized breeds (Akita)

Standard Height Male: 67 cm (Range: 64–70 cm / $25\frac{1}{4}$–$27\frac{1}{2}$ in.)

Female: 61 cm (Range: 58–64 cm / $22\frac{7}{8}$–$25\frac{1}{4}$ in.)

Weight Range Male: 35–45 kg (77–99 lbs.)

Female: 35–45 kg (77–99 lbs.)

BREEDS NOT OFFICIALLY RECOGNIZED

■ Spitz

Height Male: 30–38 cm ($11\frac{3}{4}$–15 in.)

Female: Slightly smaller

Weight Male: 5–6 kg (11–$13\frac{1}{4}$ lbs.)

Female: Same

■ Japanese Terrier

Height 30–33 cm ($11\frac{3}{4}$–13 in.)

Weight 3–5 kg ($6\frac{5}{8}$–11 lbs.)

■ Chin

Height Male: 25 cm ($9\frac{7}{8}$ in.)

Female: Slightly smaller

Weight Male: 2–3 kg ($4\frac{1}{2}$–$6\frac{5}{8}$ lbs.)

Female: Same

■ Tosa

Height Male: 60 cm ($23\frac{5}{8}$ in.) or more

Female: 55 cm ($21\frac{5}{8}$ in.) or more

Weight Male: 80–90 kg ($176\frac{1}{4}$–$198\frac{1}{4}$ lbs.)

Female: Same

* Hokkaido and Kai are a little smaller than the standard for the medium-sized dog.

The Nippo Standard for the Japanese Dog

The Standard for the Japanese Dog, which divides dogs into three classes, large, medium-sized, and small, was first formulated and laid down in 1934 by Nippo (known officially as the Nihonken Hozonkai). The purpose of the Standard was "to establish the distinctive features and qualities of the Japanese dog, as a guideline to indicate the kind of dog that we should aim to produce and breed in the future." The Standards used by associations in Japan and abroad that recognize Japanese dogs have all been developed on the basis of this Standard.

The Nippo Standard sets out a picture of the ideal Japanese dog in highly austere, exact language, in sentences that are a concentrated expression of the conditions and the culture surrounding the early breeding of Japanese dogs in Japan and of a particular Japanese aesthetic. The style is extremely concise, which gives the text all the more dignity and authority. Japanese dog enthusiasts like to read the lines of the text over and over again and ponder their meaning, as they work out the kind of ideal they should try to aim for in their dogs.

Most of the text of the Standard is written in a rather difficult style, so what is given here is a brief outline, based on the guidelines produced by Nippo for the general reader. Breeders and fanciers may want to check the information in this section against photos to try to work out what constitutes the ideal figure and form for Japanese dogs.

BASIC OUTLINE OF THE STANDARD

—Applies to the six officially recognized breeds: Akita, Shiba, Kishu, Shikoku, Kai, and Hokkaido

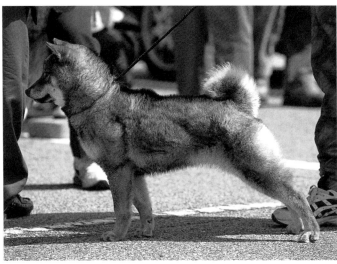

Shiba at the Nippo Show. This dog's form is well balanced.

1. ESSENCE AND EXPRESSION

The most important quality for the Japanese dog is that it possess a spirited calm (in Japanese, *kan'i*), good nature (*ryosei*), and artlessness (*soboku*). Spirited calm implies bravery matched with restraint; good nature implies loyalty and obedience; and artlessness implies an uncomplicated forthrightness. All of these refer to the essence—the temperament, personality, or nature—that the dog should have. In small and medium-sized dogs the expression of this essence is in their alertness, quick movement, and nimble gait. In large dogs it is in their composure.

2. GENERAL PHYSICAL CHARACTERISTICS

This refers to the dog's overall physical features. Male dogs should appear properly masculine, and female dogs properly feminine: a distinct sexual differentiation between male and female, referred to by Japanese judges as *seichokan*, or "sex signs," is considered paramount. The body should be well balanced, with a compact skeletal structure. The muscles and tendons should be well developed, and the ratio between body height and length 100 to 110: the body is thus slightly longer than it is tall. The body of the female will seem slightly longer than that of the male.

HEIGHT AND MEASUREMENT OF EACH SIZE AND BREED

The height of Japanese dogs is measured from the bottom of the front paw to the withers (the point just behind the upper corner of the shoulder blade), while pressing down on the undercoat. (For heights and weights of the different size categories, see page 55.)

Measuring height.

3. EARS

Ears should be of a size that is in harmony with the head. They should have the shape of a scalene triangle, with the contour of the inner ear straight, and that of the outer ear slightly rounded. The ear should lean forward slightly and stand up firmly.

4. EYES

Eyes should be somewhat triangular and slant upward to the outer corners, and be deeply set with a forceful look. Black irises, or conversely irises with pale coloration, are a fault. The ideal is an iris that is very dark brown.

5. MUZZLE

The cheeks should be full, the bite well-knit, and the bridge of the nose straight. The sides of the muzzle should be thick, with a suggestion of fullness; the stop should be moderate (neither too shallow nor too deep). The lips should form a straight line, with no hint of slackness. The tip of the nose should be black in non-white dogs, and in white dogs, a very dark brown. The dog should have the full complement of forty-two healthy teeth and a scissors bite (the top incisors just overlapping the bottom). Missing teeth and spots on the tongue are faults.

6. HEAD AND NECK

The forehead should be broad and the cheeks well developed. The neck should be sturdy, of appropriate length for the head and body. The neck should be strong and free from throatiness (loose skin at the underside of the neck).

7. FORELEGS

Seen from the front, the forelegs should form a straight line from the shoulders to the ground and be parallel. The elbows should turn neither in nor out. The width of the stance should match the width of the shoulders. The pasterns should have appropriate angulation, and the toes should be aligned and well knuckled-up.

8. HIND LEGS

The hind legs should be well developed, resilient, and strong, with correct angulation of the hock joint. The width of the stance should match the width of the hips. The dewclaw, commonly seen on the Kishu, should be clipped within two or three days of birth.

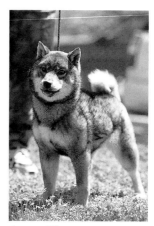

A sesame Shiba.

9. CHEST

The forechest should be well developed, the ribs moderately sprung and oval ("egg"-shaped). Chest depth that is half the body height is good; chest depth must be at least forty-five percent of body height.

10. BACK AND LOINS

The topline, from the base of the neck to the base of the tail, should be straight. The hips should be strong, and when the dog walks there should be no rolling or swaying ("fishtail") motion.

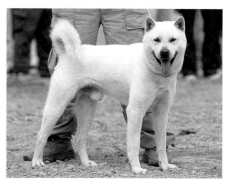

A Kishu.

11. TAIL

The tail should be moderately thick, and strong and powerful. It should be either curled or sickle. In length, it should nearly reach the hock joint. A curled tail is, just as the name implies, curly. A sickle tail is carried up over the back, but slants forward, without making a curl. This type of tail is commonly seen in the Kishu. A curled tail is a requirement for Akita.

12. COAT

The hairs of the outer coat should be stiff and straight, with clear coloration. The undercoat (*watage*, or "cotton-wool coat") should be very thick, dense, and plush, and white in color. There are five coat colors for Japanese native dogs: sesame, red, black, brindle, and white. The ideal colors for Shiba are red, sesame, or black; eighty percent of Shiba dogs are red. An overwhelming number of Kishu are white, and there are hardly any Kishu of the other colors. Shikoku are mostly sesame, though some are red and a very few are black.

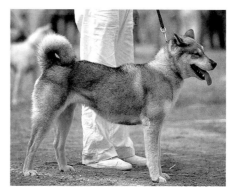

A Shikoku.

See also the diagrams on pages 88–91.

Nippo

PRESERVING AND PROTECTING THE PEDIGREES
OF THE SIX JAPANESE BREEDS

Nippo was founded in 1928 in order to preserve and protect Japanese native breeds, a goal that had been advocated by informed dog enthusiasts since the early 1920s. In 1932, the group began publishing the magazine *Nihonken* (The Japanese Dog), and in 1934 it established its Standard for the Japanese Dog, which provided guidelines for the essence and ideal body types of the Japanese dogs. In 1937, it was granted recognition as an association by the Ministry of Education (now the Ministry of Education, Culture, Sports, Science and Technology), and it went on to play a central role in the preservation and protection of Japanese native breeds.

During the 1930s the Japanese government officially recognized various breeds of Japanese dog as being important embodiments of Japan's cultural heritage. The Akita was accorded the status of Protected Species in 1931; the Kai, Kishu, and Koshi no inu followed in 1934 (although the Koshi no inu has since become extinct), as did the Shiba in 1936 and the Shikoku and Hokkaido in 1937. Nippo took an active role in promoting this process of recognition, together with dog enthusiasts and academics doing research on dogs; and it also drew up a system for dog registration and the issuance of pedigree certificates. From the very start, the objective of this organization has been to protect and promote Japanese dogs, which it continues to do to the present day.

Just three breeds—Shiba, Kishu, and Shikoku—account for almost all the dogs registered with Nippo, and an overwhelming majority of registered dogs are Shiba. The small number of Nippo-registered Akita can be explained by the existence of a separate group, the Akita Inu Preservation Society (Akita Inu Hozonkai), based in Akita Prefecture, which endeavors to promote Akita dogs independently, as "local products," as it were, of Akita. Separate breed clubs and conservation societies also exist for the Hokkaido and Kai, since, although they are categorized as medium-sized dogs, some people argue that they are too small to fit the category.

Basically, these breed clubs all share a common respect for and observance of the guidelines set in the Nippo Standard. Nippo is happy to supply registration papers and certificates of pedigree to any members who apply for their Akita, Hokkaido, and Kai dogs, providing that the dogs meet the stipulated requirements. Though there may be some small areas of difference between the various independent associations, the Nippo Standard remains the basic starting point for all of them.

NIPPO SHOWS

At present, Nippo has fifty local chapters nationwide, approximately one for each prefecture in Japan. Abroad, the China Kennel Association in Taiwan and the Colonial Shiba Club in the state of Maryland are organizations of devoted fanciers of Japanese breeds, and the Beikoku Shiba Inu Aikokai in California is an affiliated association. A great deal of interchange occurs between all these groups, with judges from Japan sent overseas every year to give lectures and to serve as judges at shows, and with every effort made to increase appreciation for Japanese dogs and to improve the dogs' quality. In recent years, due in part to the rise of interest in Japanese native breeds, judges and information have begun to be sent to Europe too.

Within Japan, Nippo holds a hundred shows a year throughout the country—fifty each in spring and fall. Every November there is a national show, where all the dogs that have received the evaluation of *yuryo* (excellent) at local or regional shows over the year gather. Here prestigious awards such as the Prime Minister's Award, the Minister of Education, Culture, Sports, Science and Technology Award, and the Commissioner of the Agency for Cultural Affairs Award for that year are conferred. In these national shows, which last for two days, about a thousand dogs compete, and the whole event is a superb opportunity for breeders and enthusiasts of Japanese native breeds to show off their dogs.

Nippo judging does not involve a single system of judging such as exists in other dog shows around the world, but rather a double system that consists of individual judging (judging dogs against the Standard) followed by comparative judging (judging against other dogs). The dogs entered in the shows are divided into classes as shown in the chart on page 61, and judging is carried out in each of the classes by judges, judges' assistants, and related officials.

First of all, in the individual judging (*zettai hyoka*), the dogs are checked for missing teeth and for their bite. Male dogs are checked to see that both testicles are fully descended, and each dog's height is measured with a special scale. A preliminary evaluation is given of temperament, character, eye coloration, gait, the angulation of joints such as the hock joint, and general physical appearance. In the comparative group judging (*sotai hyoka*), the dogs are brought out into the ring and lined up in a circle in order of assigned entry number; each animal is then judged in comparison with the others, with reference to the earlier individual

Individual judging: checking the teeth.

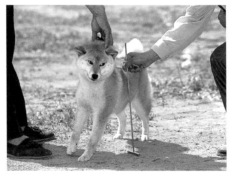

Individual judging: measuring height.

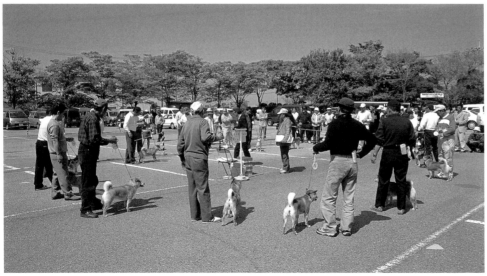

Comparative judging of Shiba.

evaluations. The judges then call out the very best dogs and conduct a further comparative investigation to determine their place in the comparative judging overall evaluation. Finally, the judges deliver their absolute evaluations of *yuryo* (excellent), *tokuryo* (very good), *ryo* (good), and a simple *ka* (pass). (All the dogs entered in the show are recognized by Nippo, so none fails.) Dogs in the *yojiken* class are assigned evaluations of *yoji-yu*, *yoji-ryo*, and *yoji-ka*; and dogs in the *yoken* class, *yo-yu*, *yo-ryo*, and *yo-ka*.

Dog shows in Japan started out as events for the amateur enthusiast, and the same basic stance continues to be observed to the present day, both by the clubs holding the events and the fanciers who show their dogs. As a result, shows are great fun and invigorating to watch. Shows are places where people can see many fine dogs and sharpen their own eye for excellence; they are also opportunities to award distinctions to a large number of dogs, in order to foster a wider appreciation of canine beauty. Rather than just evaluating the strengths and weaknesses of a dog's physical makeup, these events provide a place for participants to make an important contribution to the preservation of a part of Japanese culture.

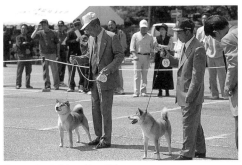
Comparative judging of two Shiba.

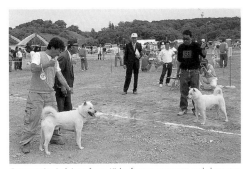
Comparative judging of two Kishu for temperament and character.

CLASSES FOR NIPPO DOG SHOWS

■ Small

Yojiken (Baby)	Under 4 months
Yoken (Puppy)	4 to 7 months
Waka inu 1 (Young Adult 1)	7 months to 1 year
Waka inu 2 (Young Adult 2)	1 year to 1 year 6 months
Soken (Adult)	1 year 6 months to 2 years 6 months
Seiken (Senior)	2 years 6 months and older

Shiba carrier box, bearing the kennel's name on the side.

■ Medium-sized

Yojiken (Baby)	Under 5 months
Yoken (Puppy)	5 to 8 months
Waka inu 1 (Young Adult 1)	8 months to 1 year 2 months
Waka inu 2 (Young Adult 2)	1 year 2 months to 1 year 10 months
Soken (Adult)	1 year 10 months to 2 years 10 months
Seiken (Senior)	2 years 10 months and older

■ Large

Yojiken (Baby)	Under 6 months
Yoken (Puppy)	6 to 10 months
Waka inu 1 (Young Adult 1)	10 months to 1 year 4 months
Waka inu 2 (Young Adult 2)	1 year 4 months to 2 years
Soken (Adult)	2 to 3 years
Seiken (Senior)	3 years and older

The History of the Japanese Dog

THE PALEOLITHIC DOG AS COMPANION

The earliest-known migrants to Japan, the Jomon people, are thought to have brought dogs to the Japanese archipelago some ten to twelve thousand years ago. The oldest dog skeletal remains discovered in Japan date from about 7500 B.C. and were unearthed in the Natsushima shell mounds in Yokosuka in Kanagawa Prefecture. Dog skeletal remains have also been discovered at a site dated to 6000 B.C. in Aichi Prefecture and one dating from 5500 B.C. in Kanagawa Prefecture. These early Japanese dogs were small, to judge from the bones that have been unearthed. During this period wolves thrived in Japan. However, these Japanese wolves have a much larger build than the early Japanese dogs, which would exclude the possibility that these dogs were domesticated wolves.

The Jomon people, who lived by hunting and gathering, eventually settled in regions all over Japan, but mainly on Honshu, with dogs as their companions. The Jomon civilization lasted nearly ten thousand years, from 10,000 to 300 B.C., and throughout this period dogs seem to have been the sole domesticated animal. They are thought to have been used as partners in hunting. Jomon people were evidently quite attached to their dogs: when their dogs died, they buried them. This is clear from the fact that skeletal remains of dogs interred with considerable care have been discovered in numerous burial sites of the Jomon period. The oldest example of a dog buried this way was found in a cave at Kamikuroiwa in Ehime Prefecture and dates from 6600 B.C.

A look at the bones unearthed from burial sites shows that this early Japanese dog was small, roughly the same size as the present-day Shiba. Furthermore, the skulls are distinguished by a long muzzle and by a

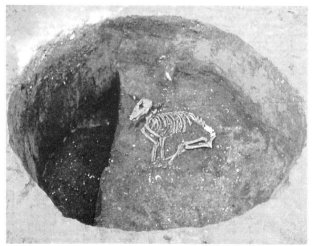

Skeletal remains of a dog found in an archaeological site in Chiba Prefecture and dating from the Jomon period. The dog's placement suggests careful burial. The model of the dog at right was reconstructed from this skeleton.

very shallow stop (the depression in the area between the eyes that connects nose and forehead) or no stop at all. It is generally believed that this early dog of the Jomon period is the ancestor of the six Japanese breeds seen today and that the prototype of the Japanese breeds was already established in the Jomon period. Earthen and clay figures of dogs from the Jomon period have been discovered in Tochigi Prefecture. The appearance of these ancient dogs, with prick ears and a sickle tail, is very similar to contemporary native breeds.

The Jomon period was followed by the Yayoi period, marked by a fresh wave of migrants, now known as the Yayoi people, to Japan from the Korean Peninsula. The Yayoi period lasted for six hundred years. Skeletal remains of dogs from the Yayoi period, unearthed in the Kuwanae burial mounds in Oita Prefecture and the Yoshinogari burial mounds in Saga Prefecture, both of which date from roughly two thousand years ago, show distinct differences from Jomon-period dogs. Their skulls have a prominent stop, and their frames are slightly larger than the early type of dog. The evidence suggests that in the Yayoi period, along with the new wave of people from the continent, a new type of dog came to Japan.

CHANGING ATTITUDES

The care and devotion accorded to the burial of dogs in Jomon sites is no longer evident in sites dating from the Yayoi period (300 B.C.–A.D. 300). Most dog skeletons are partial and scattered; they have cuts and seem to have had the flesh torn off. This suggests that in the Yayoi period dogs were eaten as food, which shows that the Yayoi people had a culture completely different from the Jomon.

Nevertheless, this new practice of using dogs as a source of food declined from the beginning of the seventh century, when Buddhism, which forbade the killing of animals, came to Japan. In addition, an ancient belief system in Japan that viewed blood and meat as a source of pollution may have contributed to the decline in the practice of eating dogs. In 696, Emperor Tenmu issued an imperial edict forbidding the eating of the meat of cows, horses, dogs, monkeys, and chickens from the fifth through the tenth months (June though November, by the old lunar calendar). It is worth noting that the edict did not forbid eating the meat of wild boar, deer, or fish.

The oldest official history of Japan, the *Nihon Shoki* (Chronicle of Japan, completed 720), records that during the reign of the Emperor Ankan (r. 531–35), warehouses were established in the various provinces

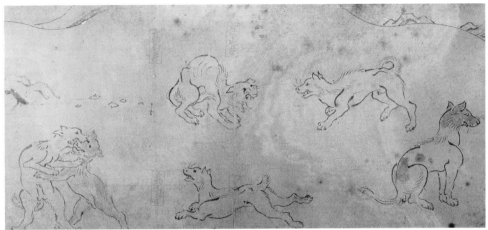

Scroll of Frolicking Animals. Heian period. National Treasure. Collection of Kozanji temple (Kyoto). The dogs depicted here have the prick ears and curly tails seen today.

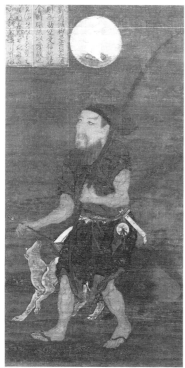

Clay dog figurines. Ca. 1600. Osaka Castle site. Osaka Center for Cultural Heritage. These figurines, only a few inches tall, would have been used as charms for pregnant women, to assure an easy delivery.

Portrait of Koya Myojin. Kamakura period. Important Cultural Asset. Collection of Kongobuji temple (Kyoto). In this scene from legend, a god disguised as a hunter is led by a white dog to the ideal site for building Kongobuji temple.

to store grain gathered as taxes. These warehouses were looked after by a special clan of people known as the Inukai-be (literally, "dog-keeping clan"). This would suggest that dogs were not only used as hunting companions and guard dogs but were also charged with the role of guarding grain from marauding rats and mice. And it provides evidence that humans were already using dogs as working animals at this early date.

Over the Yayoi period and the succeeding Kofun period (ca. A.D. 300–650), dogs were brought to Japan in at least two separate waves. In about the eighth century the genes of these later dogs were gradually hybridized with the early dogs that had existed from Jomon times, and a distinct Japanese native dog appears to have stabilized. In paintings dating from the Heian (794–1185) and Kamakura (1185–1333) periods, we see pictures of dogs with prick ears and a curly, bushy tail, the distinctive features of the Japanese dog.

For more than twelve hundred years, from the time that Buddhism became a major influence on Japanese culture, the custom of eating meat was basically avoided. Dogs were used as watchdogs and hunting dogs for centuries, and then, in the Edo period (1603–1867), people began keeping dogs as pets as well. The diminutive Chin—which had been brought to Japan from China about a thousand years earlier—was especially popular as a pet. Chin were kept as lapdogs not only by the shogun but also by high-ranking samurai families and members of the nobility. Later they also became increasingly popular among ordinary people in Edo (present-day Tokyo). They are often portrayed in ukiyoe and other paintings of the Edo period.

One of the Edo shoguns, Tokugawa Tsunayoshi (1646–1709), passed a series of edicts prohibiting cruelty to animals. Beginning in 1687, his Edicts on Compassion for Living Creatures became more and more far-reaching. The trapping and killing of all birds and animals were forbidden, and a government post—Commissioner for Living Creatures—was established and charged with enforcing the edicts. The shogun showed compassion for dogs in particular, and as a result became known as "the dog shogun." He established three large kennels in the city of Edo. It is said that one of them housed some one hundred thousand dogs by the

Puppies. Maruyama Okyo (1733–95). Painting on a cedar door. Collection of Tokyo National Museum.

Dog. Watanabe Kazan (1793–1841). Collection of Tokyo National Museum. The dog depicted here looks like a Japanese breed, though its tail is rather long.

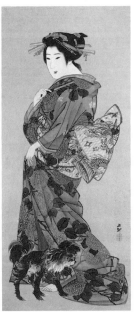

Beauty and a Chin. Mihata Joryo. Ca. 1830. Hanging scroll. Collection of Manno Art Museum, Osaka. The woman is shown pulling at her kimono while the Chin stands on the hem.

Ivory *netsuke* carving of a dog (right) and a puppy (left). Edo period.

end of its first year of operation. Tsunayoshi's nephew and successor, Tokugawa Ienobu, rescinded the edicts soon after he took office in 1709. Dogs were occasionally eaten after that, but the practice never became a custom.

THE START OF PRESERVATION MOVEMENTS AND BREED STANDARDIZATION

In the years following Japan's opening to the West in 1868, ideas about animal welfare took hold in Japan, and any lingering practices of eating dog meat disappeared almost entirely. During the late nineteenth and early twentieth centuries, all sorts of dogs were imported from abroad, particularly from Europe. In urban regions, crossbreeding between Japanese and foreign breeds proceeded rapidly. But in rural areas from Hokkaido to Kyushu, Japanese indigenous breeds, mainly used by hunters, were protected as local dogs and their integrity preserved.

In the latter half of the 1920s, amid growing national interest and pride in things Japanese, the movement to preserve Japanese dog breeds flourished. The story of the loyal Akita dog Hachiko, which became very well known at about this time, greatly advanced the cause of the Japanese dog preservation movement. The Ministry of Education gave several Japanese dog breeds official recognition as "natural monuments" (Protected Species): the Akita dog received its designation in 1931, the Kishu and Kai in 1934, the Shiba in 1936, and the Shikoku and Hokkaido in 1937. Preservation associations were established for each breed, and breed standardizations formulated.

The movement to protect and preserve Japanese dogs that began at this time was dealt a tremendous blow by the Second World War and its aftermath, when there were severe food shortages throughout the country.

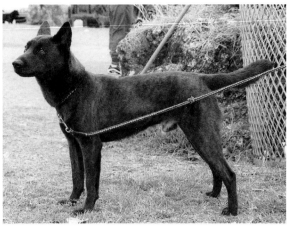

The Ryukyu that won first prize at the dog show held by the Ryukyu Inu Preservation Society in 2002.

Nevertheless, after the war, thanks to the strenuous and unceasing efforts of Japanese dog conservation societies to restore, maintain, and preserve native breeds, Japanese dogs survived and began to flourish. One consolation in these difficult years was the fact that the indigenous breeds preserved as hunting dogs by hunters in the remote mountainous regions of Japan could be used for the purpose of restoration.

Apart from the six breeds above, several other breeds should be mentioned here. One is the Chin, which was developed in Japan during the Edo period. The Chin was in fact brought to Japan from China many centuries before, and is altogether different in its morphology from other Japanese dogs, so its development does not seem to have involved any exchange of genes with Japanese indigenous dogs. There is also the Ryukyu dog, named for the subtropical island chain that arcs southwest from Kyushu. The Ryukyu is a breed of Japanese indigenous dog that followed its own separate course of development; found in the Yanbaru region in the north of Okinawa Prefecture and on Ishigaki Island, it was designated a Protected Species by the Okinawa prefectural government in 1995. In addition there are the Mikawa dog of Tokushima Prefecture and the Satsuma dog of Kagoshima Prefecture—this last was once thought to have become extinct. Both of these breeds have their own preservation movements, set up through the efforts of fanciers and enthusiasts.

GENETIC EVIDENCE FOR THE ROUTES DOGS TOOK TO JAPAN

Canine migration has accompanied human migration now for thousands of years. Research into the genetic composition of different dog populations tells us about dog lineages and migration routes and also gives us a glimpse into the lifestyles of the people who lived with the dogs. The greater the differences in genetic composition of one dog population from another, the earlier the two can be assumed to have diverged.

In recent years, studies of the relationships between dog populations in Japan and East Asia have been conducted by surveying the frequency of genes controlling blood protein polymorphisms (see chart on page 67). Research teams from Gifu University and Azabu University took blood samples of indigenous dogs in Japan and of dogs in various countries in East Asia such as Taiwan, Korea, Mongolia, and Indonesia, as well as of dogs in Europe—over five thousand dogs in all. Results published in 1991 and 1996 by Professor Yuichi Tanabe of Gifu University and his associates showed that the genetic composition of Japanese and Western breeds differed. They also showed that Japanese breeds could be divided into several groups. These groups were as follows: the "A" group includes: the Hokkaido; the Ryukyu; the dogs native to the southern island of Iriomote; and the dogs native to the southern island of Yakushima. The "B" group includes: the San'in Shiba; the dogs native to Tsushima; the Jindo and Chejudo dogs of Korea; and the native dogs of northern Sakhalin.

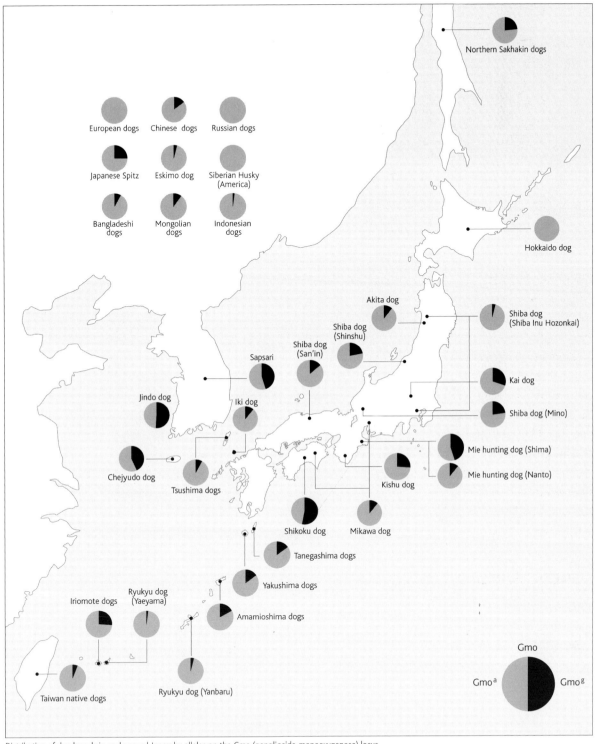

European dogs

Chinese dogs

Russian dogs

Japanese Spitz

Eskimo dog

Siberian Husky
(America)

Bangladeshi
dogs

Mongolian
dogs

Indonesian
dogs

Northern Sakhakin dogs

Hokkaido dog

Akita dog

Shiba dog
(Shinshu)

Shiba dog
(San'in)

Shiba dog
(Shiba Inu Hozonkai)

Sapsari

Kai dog

Shiba dog (Mino)

Jindo dog

Iki dog

Mie hunting dog (Shima)

Mie hunting dog (Nanto)

Chejyudo dog

Tsushima dogs

Kishu dog

Shikoku dog

Mikawa dog

Tanegashima dogs

Yakushima dogs

Iriomote dogs

Ryukyu dog
(Yaeyama)

Amamioshima dogs

Taiwan native dogs

Ryukyu dog (Yanbaru)

Gmo

Gmo^a

Gmo^g

Distribution of dog breeds in and around Japan by alleles on the Gmo (ganglioside-monooxygenase) locus.

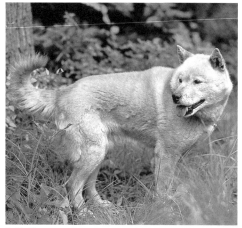

Hokkaido.

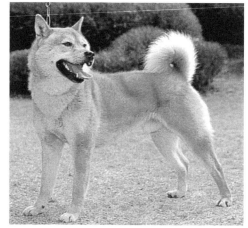

Jindo (a breed from Korea).

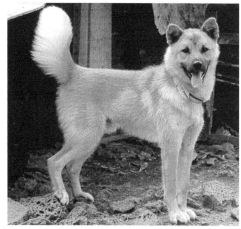

Chejyudo (another breed from Korea).

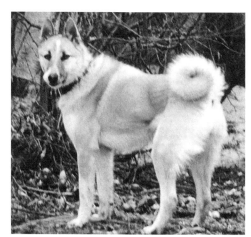

Dog native to northern Sakhalin.

The "C" group includes: the Akita; the Kai; the Shiba (except the San'in Shiba); the Kishu; the Mikawa; the Shikoku; and the Satsuma. The members of the A group received little genetic impact from later dogs, retaining the genetic composition of the early dogs of the Jomon period. The B group had the strongest genetic impact from the later dogs that were brought into central parts of Japan via the Korean Peninsula in the Yayoi and Kofun periods (300 B.C.–A.D. 650). The C group had received considerable impact from the later dogs, and undergone considerable hybridization.

The above results allowed us to induce the following about the origins of Japanese dogs and the history of their development. In the Jomon period the early dogs entered the Japanese archipelago from southern Asia via the Ryukyu Islands. These dogs eventually spread throughout Japan. Then, during the Yayoi and Kofun periods, later dogs were brought over via the Korean Peninsula, and crossbreeding occurred with the early dogs. The dogs that resulted can be assumed to be the ancestors of most of the Japanese breeds that exist today. However, in Hokkaido and the Ryukyu Islands (especially the southernmost of the islands), remote areas separated from other parts of the country by wide expanses of sea, hardly any hybridization with the later dogs occurred at this time. So the progenitors of present-day indigenous dogs in these areas have retained the genetic composition of the early dog intact. Nevertheless, even though the genetic compositions of Hokkaido and Ryukyu dogs are very similar, the breeds also possess certain features that are very distinct.

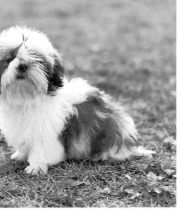
Shih Tzu (originally from China).

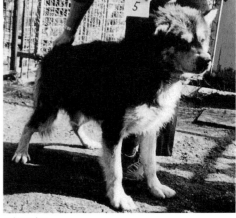
Eskimo dog.

This suggests the possibility that a group of dogs that originally had a common gene pool entered the Japanese archipelago via different routes, north and south, and that in the north another, very different group of dogs arrived later and contributed different sets of genes.

In 1999, researchers led by Professor Naotaka Ishiguro of Obihiro University of Agriculture and Veterinary Medicine analyzed the mitochondrial D-loop DNA base sequences of ancient dog bones unearthed from a number of archaeological sites from the Yayoi and Jomon periods. Their results showed that one DNA type was held in common from Hokkaido to eastern Japan, and another type was common to dogs from eastern Japan, central Japan, and western Japan. In 2001, researchers led by Professor J. H. Ha of Kyungpook National University and Professor Yuichi Tanabe of Gifu University conducted a comparative analysis of microsatellite DNA types among Japanese dogs, Korean indigenous dogs, Chinese indigenous dogs, and Eskimo dogs. Results from this study showed that the DNA type of Japanese dogs is more complex than that of Korean indigenous dogs.

What these studies make clear is that the route taken to Japan by the ancestors of today's Japanese breeds was one that took many turns and incorporated many smaller trails.

—Yuichi Tanabe
Professor Emeritus, Gifu University

THE RYUKYU DOG OF OKINAWA

The Ryukyu inu was indigenous to the Yanbaru region in the northern part of the island of Okinawa and to Ishigaki Island, one of the Yaeyama Islands at the southernmost tip of the Ryukyu archipelago, the long chain of roughly a hundred islands to the southwest of Kyushu often referred to collectively as Okinawa. It has in fact only been stabilized as a breed in the last twenty years or so.

Okinawa was an area that suffered fierce warfare and bombardment in World War II, which had a severe impact on various forms of wildlife and of course had an effect on the dog population as well. Food shortages meant that during those years people sometimes were reduced to eating dogs in order to survive, with the result that the number of dogs dwindled drastically. During the American Occupation, crossbreeding with Western breeds took place and native dogs all but disappeared. Then, in the early 1980s, a group of dogs that had gone wild was discovered deep in the subtropical rainforests of the Yanbaru region. Thirty or so were rounded up, and the results of testing showed a distinct difference between their blood samples and those of dogs in the main islands of Japan and European and American breeds. These dogs had a genetic makeup that resem-bled that of the Hokkaido dog, and in their physical appear-ance too they showed the same shallow stop and the same black spots on the tongue.

These investigations attracted a lot of attention to the dogs as a breed that was in all likelihood unique to Okinawa, and the Ryukyu Inu Preservation Society (Ryukyu Inu Hozonkai) was founded with the objective of propagating and protect-ing the breed using the group of dogs that had been discovered as a genetic base. In the course of efforts to produce features of the original Ryukyu dog by means of judicious interbreeding and to stabilize the breed, the numbers of such dogs gradu-ally increased, and in 1995 the Okinawa prefectural govern-ment designated the Ryukyu a Protected Species. At present, there are two officially designated lineages, arising out of slight differences in build and temperament, whose names derive from the areas where they were found—the Yanbaru strain and the Yaeyama strain. It is thought that there are only between seven and eight hundred Ryukyu in Japan today. Most Japanese will have heard of the breed but will probably be unsure what it looks like.

People in Okinawa have always referred to dogs using the words *turaa* or *aka-in*. *Turaa* is the Okinawan pronuncia-tion of *tora*, or "tiger," while *aka-in* is a rendition of *aka-inu*, "red dog." These terms surely derive from the physical char-acteristics of the dogs that people came into contact with most often in their daily lives, and indeed the coats of Ryukyu dogs are basically of two types, brindled (*torage*, literally "tiger fur") and various shades of brown, including tawny red. This suggests that at one time these dogs must have been extremely common in Okinawa. There are three kinds of brindled dogs—red brindle, black brindle, and white brindle.

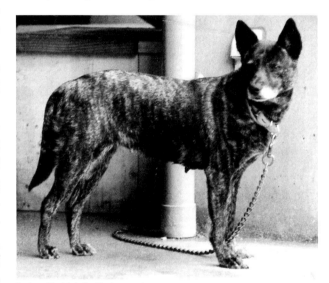

Ryukyu. Black brindle, Yanbaru strain.

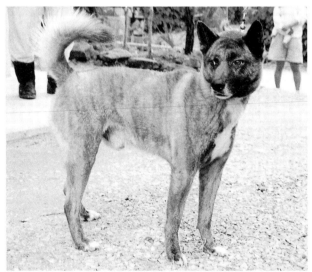

Ryukyu. Tawny red brindle, Yanbaru strain.

Even the solidly colored brown dogs show a great deal of subtle variation in their coloration: they can be tan, fawn, or dark brown. Altogether there are ten categories of color for this breed.

Ryukyu inu are medium-sized dogs, with the Yaeyama strain tending to be slightly larger than the Yanbaru. Dogs that are slightly long in the body are held to be the ideal. Ryukyu dogs look very much like wild dogs, which gives the impression of extreme ferocity, but, quite to the contrary, their disposition is mild and amiable and they make loving pets. Nevertheless, they have a strong territorial instinct, and they are not necessarily good with other animals. At one time they were used to hunt wild boar, and one should bear in mind that their hunting instinct is alive and well.

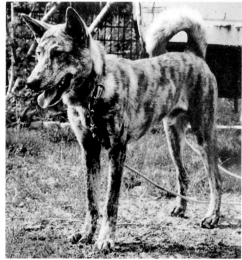

Ryukyu. Black brindle, Yaeyama strain.

JOMON SHIBA: A DOG FROM PALEOLITHIC TIMES RECREATED BY CONTEMPORARY BREEDERS

Nowadays we know the Shiba inu as a chubby-faced, cute little dog, but there is a completely different strain of Shiba inu that is much less well known abroad and yet has its own devoted fanciers in Japan. This is the Jomon Shiba. As was mentioned, the word "Jomon" refers to a civilization that lasted from about 10,000 to 300 B.C., which archaeologists named after the characteristic rope pattern on earthenware found in archaeological sites of the period. The Jomon period in fact covers an extraordinarily long span of time, during which people lived by hunting, fishing, and collecting plant foods. They used stone tools and pottery and, toward the end of the period, resided in settled communities.

Jomon archaeological sites can be found all over the Japanese archipelago, and it is remarkable how many of them contain the skeletal remains of dogs. The Jomon Shiba is the name for the dog that has been recreated on the basis of the frames of the dogs found in Jomon sites. A few dedicated breeders in Japan have made it their mission to recreate this ancient breed scientifically on the basis of these skeletal remains, as well as to preserve its bloodline and propagate it. These breeders constitute the Tennen Kinenbutsu ("Protected Species") Shiba Inu Hozonkai (SHIBAHO).

The main difference between Jomon Shiba and the Shiba as most people know it today is that the Jomon Shiba looks much fiercer—in fact, it looks like a wild dog. Japanese dogs in ancient times were rather similar to the Japanese wolf (*Canis lupis hodophilax*, a now-extinct subspecies of the Gray Wolf), and Jomon Shiba do closely resemble these miniature wolves (the Japanese wolf was in fact the smallest wolf in the world). Indeed, the Jomon Shiba breeders specifically strive to heighten these wolflike physical features.

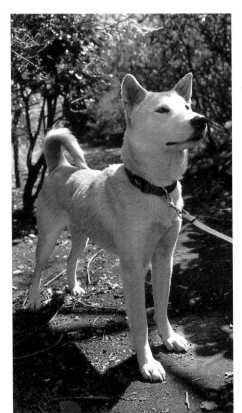

Jomon Shiba.

Year-old Jomon Shiba puppies.

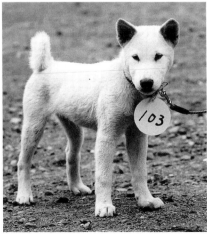

White Jomon Shiba.

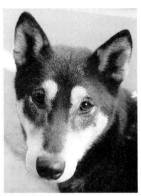

Black Jomon Shiba.

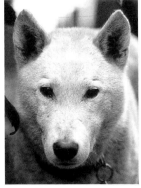

Jomon Shiba.

Specifically, the Jomon Shiba's most important distinguishing characteristics include its narrow, lean head, its shallow stop (making a smooth line between forehead and muzzle, with hardly any drop in the area of the nose), as well as its large teeth. Nowadays, there seems to be a general preference among breeders and, indeed, the general public for breeds with deeper stops, which makes their muzzles seem short and teddy bear–like. This is the result of a general yearning for pets that look cuddly and cute. However, if reproduction is left to occur naturally, the Shiba inu will lose that marked stop and the whole face appear longer and leaner as a result—in other words start to become the face of a Jomon Shiba. The temperament of the dog will change too, becoming much more independent and adult. One byproduct of this independent spirit is that the dog becomes less tolerant of other dogs and of unfamiliar people. However, toward its owner, as toward the leader of a pack, it becomes all the more obedient—and if it is part of a team or pack it will fight to protect the other members. There are some who claim that Jomon Shiba are difficult to train, but perhaps we should bear in mind that they have their own unique history—one that reaches back to Paleolithic times—and that this should be respected. They should be allowed to retain something of their primitive aspect, and should be owned by people who want to use them in activities like hunting.

Among ordinary Japanese, the Jomon Shiba is probably even less well known than the Ryukyu, although because of the number of devoted Jomon Shiba fanciers, there are probably more of these dogs than Ryukyu.

Jomon Shiba possess an innate ability to hunt, and the few people who still hunt in Japan in this day and age have been the ones who have lent most support to the efforts to preserve this ancient breed. It is truly remarkable that these dogs can once again be seen in Japan. Japan's being an island country is no doubt one reason that it has been possible for breeders to recreate the Jomon Shiba.

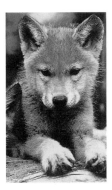
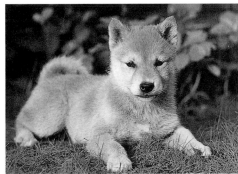

The photo at the far left shows an American timber wolf cub, while that at the immediate left shows a Jomon Shiba puppy. It is extremely hard to tell them apart.

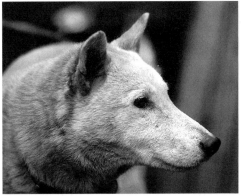
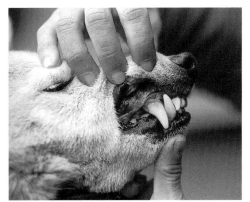

Jomon Shiba head and teeth. A profile view shows that the stop is almost nonexistent in this breed. The teeth are large and powerful, especially in proportion to the head.

Hunting and Japanese Dogs

HISTORY

The excellent hunting ability of Japanese dogs is surely one of the main reasons why they have survived down through the centuries to the present day. Their unique temperament—which combines absolute obedience and loyalty toward their master with incredible courage and daring toward the animals they hunt—has meant that they have always been invaluable companions, beloved by hunters for both practical and emotional reasons.

For people in ancient times hunting and gathering were activities on which their very survival depended. Long before people kept any other kind of domestic animal they kept dogs, and from well before the spread of agriculture, humans and dogs lived an existence of mutual dependence: dogs were their owners' hunting partners. As we have seen, in archaeological sites of the Jomon period (10,000–300 B.C.), discoveries have been made of numerous dog skeletons; some have even been found arranged close by and around the human skeleton in a way that suggests careful placement for protection from malevolent influences. In other cases a dog's remains have been found nestled in a skeleton's arms, suggesting a close bond.

During the Yayoi period (300 B.C.–A.D. 300) agriculture became widespread and settled communities became the norm, with the result that hunting lost its central importance in people's lives. The status of dogs changed too. Once a partner with a special significance for human beings, the dog now seems to have become more of a tool valued for its usefulness: the main role of dogs in the communities coming into existence at this time seems to have been as a watchdog that could give warning of the approach of large wild beasts and intruders; dogs also started to figure in human beings' diet.

In the Kofun period (ca. A.D. 300–650), hunting with dogs seems to have become still less common. The various earthenware figures (*haniwa*) found in the burial tumuli that characterize this time include categories of animal, and from the first half of the fifth century A.D. earthenware figures of wild boar and deer make their appearance, often in sets that feature dogs. In the Hodota archaeological site in Gunma Prefecture, sets of animals have been found along with a figure of a hunter holding a drawn bow. Such haniwa are very suggestive of a scene of a hunt, but archaeologists think that their purpose was in fact to represent some sort of hunting ceremony held by the community chief, and that the chief purpose of hunting at this time was ritualistic, to demonstrate authority.

In short, hunting with dogs once held a position of central importance in society, but it gradually grew less important and less widespread. In later ages, dogs were used in hunting almost exclusively by professional hunters, though some samurai warriors also hunted with dogs as a way of fostering their martial spirit, or as a hobby, or as a form of entertainment. In other words, dogs' innate hunting abilities were fostered mostly by people who hunted for a living, and this tended to be in particularly isolated parts of the country where steep mountain ranges prevented contact with other regions. This not only helped to reinforce the Japanese dogs' hunting abilities, it also meant that these dogs were prevented through natural circumstances from crossbreeding with dogs brought to Japan from overseas. In fact it was dogs from these isolated mountain areas, as well as dogs kept by professional hunters, to which Nippo paid particular attention in the first decades of the twentieth century when it was formulating its Standard.

Nowadays most of the hunting done with dogs in Japan is of wild boar (*Sus scrofa leucomystax*) and Japanese deer (*Cervus nippon*; also known as Sika deer), and the overwhelming majority is of wild boar. Some hunting is also apparently carried out of Japanese bears (*Ursus arctos* in Hokkaido, and *Selenarctos thibetanus* in the rest of the country), but only in very limited numbers. As for the breeds of dog used, nearly all dogs used nowadays in hunting wild boar are Kishu inu. The Shikoku, Kai, and Hokkaido are also used, but not nearly as much as the Kishu.

In the hunting of wild boar and deer, the dogs first follow the scent of an animal, then track the animal down, encircle it, bark at it as it tries to flee, and close off all possible escape routes. This is called *hoe-dome*, or "baying" (literally, "barking to detain"). If the hunted animal tries to force its way past the dogs, some dogs are trained to prevent this by leaping onto its neck, hind legs, or buttocks and latching onto these body parts with their teeth. This is called *kami-dome*, or "biting to detain." This is done only to pin down the prey and never to kill, and since most hunting is done with at least two dogs working as a team, nearly all dogs used are the *hoe-dome* type. Kishu inu are the dogs most often used for both *hoe-dome* and *kami-dome*.

Shiba inu have unique hunting skills that are particularly suitable for hunting wild birds. These consist of making pheasants and mountain birds panic and run up trees, called *ageki-ryo*, or "treeing"; and barking so that ducks gather in one area, called *yobiyose-ryo*, or "duck tolling." In steep mountain ranges, the hunting of mountain birds was once the sole province of Shiba inu. Nowadays, however, it has become much harder to find a Shiba inu that has such skills. The same is true of Akita inu, which are rarely seen in hunting situations today. In the past there was also a special type of Akita used specifically for hunting, known as the Akita matagi inu, but this no longer exists. Japanese dogs have made the transition to show dogs and prize competition dogs, and Shiba and Akita in particular are bred for appearance rather than hunting ability. As a result, only Kishu, Shikoku, and a very few Kai and Hokkaido are used by people who hunt, and the unique skills of the Shiba and Akita are for the most part no longer employed.

Nowadays even though only a few of the Japanese breeds are used for hunting, a small section of devoted fanciers are intent on increasing their number and preserving their bloodlines. Most hunters have not paid too much attention to the bloodlines of their dogs: their main focus has been on getting the job done—for them, all that matters is whether the dog manages to get the game. Recent years have even seen the appearance of a dog known as the "hybrid dog" (or "mongrel"), suggesting that people who place a premium on using purebred Japanese dogs when they hunt are in the minority. But the particular abilities that Japanese breeds display when hunting are the very same abilities as those of their ancient forebears, which shows that their bloodlines as hunting dogs have been preserved even to the present day.

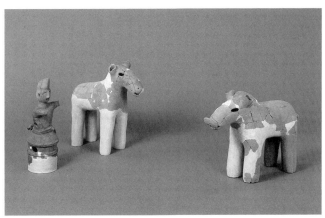

Earthenware figures of a hunting scene (hunter, dog, and wild boar) dating from between the fourth and seventh centuries A.D. Hodota archaeological site, Gunma Prefecture.

The number of animals that are available to be hunted in Japan has been greatly reduced due to deforestation and land development. What with the influence of animal welfare movements and increasing restrictions on the already highly regulated use of firearms in Japan, limitations on game hunting continue to increase. But even under such disadvantageous conditions, hunters are determined to keep searching for a style of hunting that can draw on the experience of their predecessors and still reflect values of the modern age. The changes in the Japanese breeds used in hunting are an example of such adaptation. Japanese dogs will continue to survive as hunting dogs, adapting to new conditions and requirements but never losing their special characteristics, their quick reflexes, stamina, resilience, and feistiness, as they were developed in the steep forested hills and mountains of Japan, especially now that they are protected by the Nippo Standard.

HUNTING WITH THE KISHU INU

"For the hunter the best kind of dog is the dog that performs well in the hunt. For us it's that simple." Hiroshi Suzuki and Hiroshi Nagasawa are two hunters who agree that what they want from a dog is not whether it conforms to any official dog standards in physical appearance or temperament, but simply good hunting ability. Both men hunt with Kishu inu, and if they care about their dogs' bloodlines at all, it is only insofar as the dogs come from good hunting stock. And certainly the dogs they use are quite different in their physical appearance from show dogs. To put it bluntly, they haven't a trace of dignity or refinement: it would be more accurate to describe them as rough and uncouth. But, according to Suzuki and Nagasawa, on the hunt they'll race up and down mountain slopes after game with great persistence and toughness, and when they manage to corner an animal, they'll confront it with courage, quite undaunted. Kishu inu are mostly used to hunt wild boar and deer, which in Japan are categorized as large game. But they are just as capable of hunting bear, though they are rarely used for that today.

When the hunting season begins, hunters set off together and go up into the mountains, working in groups and using their dogs as beaters, to drive out the game from under cover. Most of the hunting expeditions are arranged by local hunting associations, and an overwhelming proportion are in response to requests from local governmental bodies to exterminate wild animals that either pose a menace or are a nuisance to human beings. In certain areas the number of wild boar or deer may have increased so much that they emerge from the forest near populated areas and farmland, trampling and eating crops, so that they are seen as pests needing to be culled.

"We'd prefer to be able to hunt for enjoyment, as a form of sport," Suzuki explains. "But mostly when we hunt during the year it's a kind of duty. We're more like wardens who are managing the land using guns. As soon as November comes around, though, when the hunting season begins, we'll be out on hunts in the mountains and hills almost every weekend. So we've got to keep our hunting dogs ready—fit and prepared."

The two dogs Suzuki takes with him when he hunts are called Boke and Nasu. To Japanese ears his dogs' names sound rather insulting, especially when called out together ("Boke nasu" translates as "Knucklehead"), but Suzuki, who has a passion for Kishu inu, insists that they were chosen out of affection. Boke and Nasu know Nagasawa's dog, who is called Nuts, since they're often taken out on hunts together, and the number of successful hunts they've had shows that they're a highly effective team.

Hunting dogs are bred to catch wild animals so they have to have a strong prey drive, but toward their owner, the owner's family, and familiar dogs they are amiable and cooperative, according to Suzuki and Nagasawa. Dogs that take an aggressive attitude toward other dogs out of loyalty to their own master are more suited to work as watchdogs than hunting dogs. Aggressive dogs are fine if you're simply trying

out their hunting ability in an enclosed area, putting them up against a wild boar. But on the loose, such dogs are actually extremely dangerous. There's no telling what kind of disaster they might cause if they were to encounter another dog or a human being.

Out on the hunt, once the dogs are let off their leads they are completely beyond the jurisdiction of their master. As they drive animals out of cover and chase them down, dogs have to make decisions and act entirely on their own. The ferocity of dogs that hunt boar and deer is often mistaken for evidence of an unruly, quarrelsome nature, but in fact a quarrelsome dog would never be able to act effectively and use its own judgment. The best hunting dogs—and this applies to dogs that hunt smaller game too—are those that keep a cool head in any situation. Instinctively, the best hunting dogs know that it's not other dogs they should be after, but the game.

Another important characteristic hunting dogs should possess is caution, even to the point of cowardice. The courage required of dogs involved in hunting can sometimes mean that at times they end up getting seriously injured. If they've managed to corner a boar, for example, and are harrying it, choosing the right moments to rush forward and bark at it, in a flash the boar might come lunging back, goring a dog with its tusks. If a dog is just an aggressive bully, it will keep getting injured time and again, and sooner or later end up getting killed. Experienced dogs will know instinctively how close they can get to the game, and the most skillful ones will know that it's safer to keep more distance than less. The better the dog is as a hunter, the more it will appreciate that boars are dangerous animals—though that won't stop it from going after them. The ideal dog will know that it can't overpower a boar by simply attacking it head on, say Suzuki and Nagasawa. It'll want to work as a team with its owner and also with other dogs.

"The kind of dog we want is one that's intelligent and crafty, slightly cunning, a dog that'll keep harrying the boar persistently, even to the point of persecution. One that'll attack, then draw back, and then attack again, getting just the right timing, and gradually squeeze the boar into a tighter and tighter corner. The sight of this makes us proud. Sometimes the dog will do it with a kind of wicked enjoyment so that even its owner will think it's taking things too far, and the other guys on the hunt will tease him and accuse him of having a sadistic brute of an animal." Once the dog manages to get the boar into a corner, the hunters can get up close and shoot it.

Hoe-dome. A Kishu baying before a wild boar.

To have their dogs described as sadistic brutes doesn't seem to worry these two men. If anything, it's proof that their dogs have the requisite hunting spirit, and ironic comments like these are a source of pleasure—the best kind of compliment for hunters who have always considered that the only kind of dogs to hunt with are Kishu inu.

Suzuki and Nagasawa's years of experience of hunting with Kishu inu have shown them, they say, that smaller Kishu make the better hunting dogs. Bigger dogs are good for dragging animals down and latching on to them with their teeth, but their bulk also makes them easy targets for boars' tusks. Smaller dogs don't even have the option of pinning the prey down, and as a result they are wounded much less often. They do look for chances to bite the prey, but biting is just one of their maneuvers, and they usually simply chase the boar down and bark at it fiercely. If you use several dogs, it's possible to make them work with each other, and so it doesn't matter how small they are. And if you're hunting in the mountains, small dogs are suitable for pushing through the heavy undergrowth—they'll chase game out from the deepest cover that humans would have no hope of getting anywhere near. Incidentally, Suzuki and Nagasawa claim that bitches are much better than dogs when it comes to harrying a cornered animal: they have a special resilience and tenacity.

Once Suzuki and Nagasawa got started on the topic of Kishu dogs' qualities as hunting dogs, they talked on and on, one story following another. Everything they said about Kishu inu was filled with admiration and affection: clearly, these hunters were obsessed with their dogs. They said they made sure to take their dogs up into the mountains all through the year, even outside of the hunting season, to give them training and keep them at peak fitness. These two men were determined to develop the full innate abilities of Kishu inu as hunting dogs, and to make sure that these abilities can be passed down to succeeding generations.

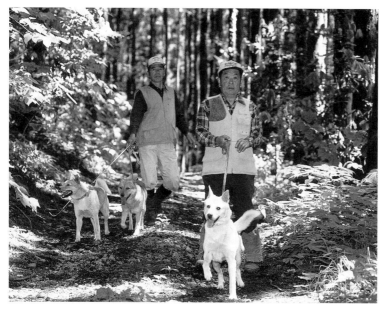

Hunters in Gunma Prefecture setting out with their Kishu.

HUNTING WITH THE AINU INU

Masao Kimura has worked for decades as a professional hunter in the Tanzawa region, a moun-
tainous area in Kanagawa Prefecture, near Tokyo. He trained and worked with Akita and Kishu
hunting dogs for many years before first encountering the Ainu inu—with its unique attitude
and skills—about twenty years ago. He has kept Ainu dogs ever since, and often uses them in
packs on large-scale hunts for boar or deer. He continues to use the reliable Kishu as well, but
admits that the intense and fearless Ainu is actually his favorite. Here he describes working with
these dogs—their temperament, their unique hunting skills, and their struggle to adapt to the
climate of Japan's main island, which is much warmer than their native Hokkaido.

I well remember the first time I saw an Ainu inu. It was when I attended an Ainu inu meet held near
the Shizunai River in southeast Hokkaido. A square, stocky dog was harrying a huge brown bear and
displaying the most incredible courage and ferocity—and from that moment, you could say, I was
hooked. I decided right then and there that I had to have one of these dogs to hunt with. At that time I
hunted with Shiro, my Kishu inu, a bitch, and I'd heard it was just about impossible to keep Ainu inu
as hunting dogs anywhere in Japan except Hokkaido, but still I wanted to have a try. (Incidentally,
hunting with Ainu inu is rare even in Hokkaido now, since there are so many racehorse breeding
farms and pastures there. When the racehorses are startled by dogs and wind up getting hurt, people
demand huge amounts of money as compensation, so it just isn't worth it.)

Our first Ainu inu, a puppy, joined us in February 1988. He came from Shizunai, and we called him
Chibi ("Little") though the official name on his pedigree certificate was "Ryoyuryu of Hokkaido Matagi-
so." He came from the Chitose line—renowned as one of the top Ainu stocks for hunting—you could-
n't ask for a better pedigree, not to mention that his name meant "fighter of bears and dragons." Even
so, when I eventually took him out with me, I'd get all sorts of jibes from other hunters, who'd tell me
I must be crazy to want to use a dog from Hokkaido as a hunting dog here in Honshu. "He'll be all used
up by the time hunting season comes around," they'd tell me. I'd get all defensive and retort that he

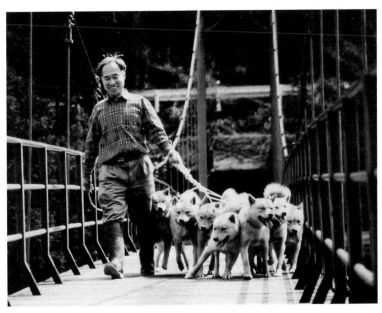

The author of this section,
Masao Kimura, is shown set-
ting off on a hunting trip with
his Hokkaido dogs in Kana-
gawa Prefecture.

came from great hunting stock, that he'd already survived two summers in Honshu, and that he was tougher than most. But this only brought ironic comments like, "Well, we'll see how he does then! It'll be a sight worth seeing!" Ainu inu come from the coldest region in Japan, and such banter reflects the common wisdom that they don't thrive anywhere else.

I was determined to raise Chibi to be the best hunting dog anyone could want, and in fact I was pretty confident that the odds were in my favor. My dog Shiro, a great hunting dog, would provide a superb example, and I was rearing Chibi in one of the cooler areas of the mainland, the foothills of the Tanzawa Mountains in Kanagawa Prefecture. I was determined to take all the proper precautions to keep his strength up and help him survive the hot summers.

Ainu inu are stockier than Kishu inu, with broader shoulders, so they're not good at all at pushing through the undergrowth. When they've chased down large game like wild boars or bears, they're often quite exhausted, with hardly any desire to hunt left. This means that they won't necessarily persist in harrying and barking at an animal once they've cornered it, and the animal can sometimes get away. The worst thing as far as a hunter is concerned is for his dogs giving chase to a game animal to decide on their own whim to call it off and just give up. There'll be any number of reasons why this happens, but one is definitely that the dogs just don't have it in them any more—they're exhausted. My Shiro would never stop, but with Ainu inu, they can happen across a marshy stream and they'll lean down to have a drink, and if that happens, it's all over.

In Hokkaido, the true home of the Ainu inu, the problems posed by dense undergrowth just don't exist. There, hunting involves the dogs looking for the tracks of game over the snowy plains, along with the hunters. There's thick snow everywhere, covering the plants and bushes completely, so pushing through undergrowth isn't an issue. But in Honshu it definitely is. There may be less snow than in Hokkaido, but there's undergrowth—all sorts of dried bushes and thickets, even in winter—and the dogs have to skillfully pick their way through as they give chase to the game. In Honshu you're unlikely to be able to see clear prints in the snow as you do on the snow-covered plains of Hokkaido, so the dog has to have a good nose and the hunter a good eye, to pick up the slightest traces of the game animal. Sure, it's obvious that the terrain in Hokkaido and Honshu would differ, but the differences show up decisively in the characteristics of the breeds, making themselves felt in the dogs' builds.

The Kishu inu is naturally adapted to mountainous and hilly terrain, while the Ainu inu is naturally adapted to northern, snowy country. Now that I've experienced keeping Ainu inu, I will acknowledge that the heat and humidity of summers in Honshu do take their toll on them. By the end of summer the dogs are exhausted. The Kishu inu, with its smaller build and narrower shoulders, has much less difficulty dashing through the undergrowth, so it keeps up its strength—and its desire for the hunt never seems to suffer either. So yes, I have to admit that the Kishu inu does better than the Ainu at hunting in Honshu.

The Ainu inu does have its own special straightforwardness though, different from that of the Kishu inu, and it also has a sort of a wildness. And of course—though this hardly needs mentioning—there's its famous ability to withstand the cold. The paws of red-colored Ainu inu in particular are said to be amazingly strong, with black claws that are completely resistant to cold and moisture, and the most incredibly tough, thick pads. Their undercoat is amazingly thick too—woolly, and almost as thick as a sheep's.

As for their weak points, they are quarrelsome, and they like to pick fights with other dogs, even their own brothers and sisters. And I've noticed that a lot of them seem to pass the peak of their physi-

cal strength quite early. I don't know whether this is just my Ainu inu, or whether this is a weak point that's shared by all Ainu inu, but they somehow give the impression of aging faster than other Japanese breeds. It's as if they age three times as fast—losing their agility quickly and becoming less able to recover completely from the aftereffects of their wounds.

And I admit now that the climate of Honshu with its hot, steamy summers does make hunting with Ainu inu difficult. These dogs find even the winters in Honshu too hot for their liking, and the summers really take it out of them. Basically, there's no denying that these dogs come from Hokkaido, and they do best in cool to subfreezing temperatures.

My first Ainu inu was a dog, and then a year later I got another one, a bitch. She was from the same line, the Chitose line, and sired by Yu. A year after that they had a litter of four puppies, all males, so altogether we had six Ainu inu. I took them hunting with me as often as I could, using Shiro to show them how it's done. In the course of roughly eight years of hunting with my Ainu inu, we've managed to catch ten wild boars and fifty deer. I think that's a fair amount of game, and it certainly proves that Ainu inu are decent hunting dogs, even if they don't quite match up to the Kishu inu.

Right now I have three Ainu inu, and since they're all a bit long in the tooth, around eleven to twelve years old, I no longer take them with me when I hunt. If someone were to ask me how I thought they did as hunting dogs, I would say that bearing in mind how much they hate the climate here in Honshu, they do well and try their best. I think the guys who've come with me on hunts would have good things to say about them too.

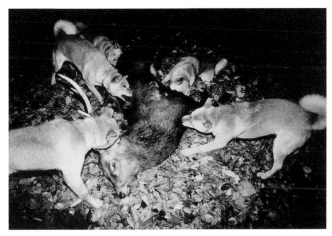

Mr. Kimura's Hokkaido dogs examine a felled wild boar (above) and deer (below).

Well-Known Dogs in Japan

TAMA: A Shiba Who Rescued His Master from Being Buried in the Snow

This story takes place in Niigata Prefecture, an area of the country that is famous for its snowy winters. In a village now known as Muramatsu, roughly in the center of Niigata Prefecture, there was a dog named Tama who in the 1930s saved his master's life—twice.

Tama's master was a man named Karita Yoshitaro, a hunter who lived by the Hayadegawa River, which runs through the center of Muramatsu. Tama had been a gift from one of Karita's neighbors, and Karita nearly always took Tama with him when he went on his hunting trips. Nowadays hunting is hardly practiced at all in Niigata, but up until as late as the 1950s, especially in the central parts of the prefecture, it was a common sight to see hunters setting out into the mountains with their dogs. Most people hunted bears, especially if they hunted for a living, but there was also some hunting of birds. Bear hunting involved using dogs to track down the game and to bark at it fiercely to keep it at bay, after which the hunter approached and shot the animal at close range. In the northern part of the country, where the mountains are covered with deep snow, the sound of a shotgun can easily trigger an avalanche, and in fact it was more common for hunters to lose their lives to the hazardous weather conditions than to the fierce animals they hunted.

On February 5, 1934, Karita and several hunting companions had set off for Yatakezawa—a mountainous area in Tohoku Prefecture—but were caught in an avalanche that had been set off when a shotgun was fired. In an instant Karita found himself buried under several feet of snow. But soon he heard the sound of his dog Tama digging frantically away at the snow with his claws, panting heavily as he labored away. Dazed with cold and on the point of losing consciousness from lack of oxygen, Karita kept calling out to the dog. The sound of Tama's claws scrabbling through the hard, dry snow came nearer and nearer. He was digging away with all his might, spurred on by the sound of his master's voice: "Tama, here boy! Here!" Finally, a large hole appeared in the snow just above Karita's head, letting in dazzling light like a halo, and there in the center was his dog Tama, panting, his breath white in the freezing air, but his whole face beaming now with delight at the sight of his master. Once his upper body was free, Karita could scramble up out of the snow, and he grabbed hold of Tama's freezing paws to try and warm them, only to find that they were raw and bleeding, their pads all torn.

The story of how Tama rescued his master from the snow spread throughout

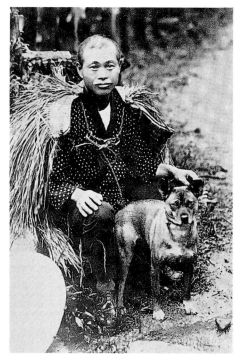

Tama with his master.

The area where Tama lived.

Muramatsu village and was featured in Niigata newspapers and on the local radio. But at this point that was the extent of Tama's fame.

Two years later, however, in 1936, Tama accomplished an even more remarkable feat. Again Karita had set out with his companions on a hunting trip, and again they were caught in an avalanche. This time, however, the avalanche was much more powerful, with waves of snow catching Karita, his companions, and Tama, sending all of them tumbling several tens of meters down the mountainside. As he careened down, rolling over, Karita saw his dog Tama come plunging along with him, and he thought to himself that this time there was no help for it: they were both going to die.

Karita lost consciousness in the torrent of snow, but when he eventually came to and opened his eyes, there right in front of him was Tama, his face smiling at him with joy. Karita asked his companions what had happened and learned that even though Tama had been caught in the avalanche along with the rest of them, somehow he had managed to scramble free, and dig his master out of the snow—and what's more, he dug out every single one of his master's companions too.

This time national as well as local newspapers took up Tama's extraordinary story. The news even spread as far as America, and Tama was received an award (in absentia) from a large animal protection group in New York.

News reports of the time all describe Tama as a Shiba. However, in physical appearance he seems to have more closely resembled a Jomon Shiba. One expert in canine studies who saw the dog stated that he thought Tama was a Koshi no inu, which with the other breeds was designated a Protected Species in the 1930s, but which sadly is extinct today.

Newspaper article describing how Tama had started to guide hunters to the best places for bear hunting.

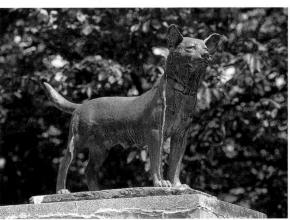

A bronze statue of Tama that stands in Tama's hometown of Muramatsu, in Niigata Prefecture.

HEIJI: The Akita Guide of Mountain Climbers

In central Kyushu, the southernmost of the four main islands of Japan, lies the majestic Aso mountain range, a chain of five volcanic peaks. The scenery here is so magnificent, with grassy highlands, lava plateaus, active craters, and craggy mountains, that together with the adjoining Kuju mountain range the area has been designated a national park, the Aso-Kuju National Park. The fame of the Aso mountain range attracts 250,000 visitors annually, including numerous hikers. However, the mountains are all quite high, with elevations of 1700 meters (almost 6000 feet) on average, so that despite their southern location they are covered with snow in winter and conditions can be lethal.

On New Year's Day in 1962, there were two separate hiking accidents in the area, and seven people lost their lives, disasters that made it clear that hiking in these mountains should not be undertaken lightly. Such disasters continued to occur, one after another, until one day a couple who came down from the approach to one of the mountains had an interesting tale to tell.

Soon after they had taken the hiking trail that leads up to Mount Kuju, it started to drizzle so they decided to take a shortcut. But then they found themselves following an animal trail and going in circles. In a while it started to grow dark and they realized they were lost. Just when they were at their wits' end and exhausted, out of the gloom appeared a great white dog, looking up at them with a quizzical expression.

"It must be someone's pet," they thought, which suggested to them that they must be close to a village. This immediately reassured them and gave them the strength to go on. The dog turned around and set off, and they simply followed it down the mountain.

The dog was in fact a stray that had made its home in the Aso mountains. Thin and clearly undernourished, with patchy, mangy fur, it was a poor-looking specimen. When the couple heard that the dog didn't have a home, they made a special visit to the park warden of that particular pass, and gave him money for medicine to treat the dog's mange as a means of showing their thanks. The warden, a man named Enokuma, used the money to make the dog fit and healthy again. In two months the dog had a thick coat of fur, and in three months it started to put on a bit of weight. At this point, people realized that the dog was in fact an Akita inu, and quite a large one.

Mr. Enokuma gave the dog the name Heiji (a masculine name, even though Heiji was a female), and since she liked to go walking so much, he decided to train her as a guide dog.

The first thing Mr. Enokuma did was familiarize Heiji with all the hiking trails in the area—all the highlands, mountains, and valleys. They walked up and down all the trails of Mount Kuju, Mount Hoshu, Hijidake Peak, Nakadake Peak, and many more. Finally, Heiji needed only to hear hikers mention the words "We're headed to Mount Kuju" for her to leap out and start leading the way.

A loner to begin with, Heiji was happy to live by herself in the mountains

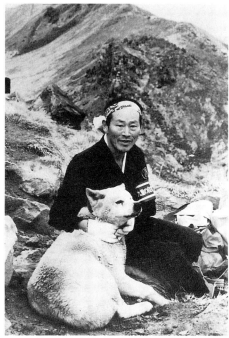

Heiji and her trainer, Mr. Enokuma

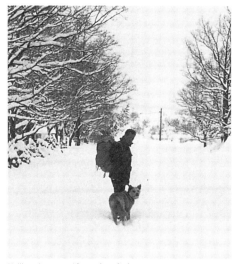

Heiji setting out with another climber.

and roam the hiking trails. Sometimes she would just appear in front of hikers and start walking ahead of them. Occasionally she guided people who had lost their bearings down out of the mountains, as she had done with the couple who first discovered her. She was given food by Mr. Enokuma and various superintendents of mountain huts and of course sometimes by hikers. For years she continued to rove the mountain ranges, never asking for any particular attention from anyone but loved by everyone nevertheless. Every person who visited the area came to know of her existence, because she was a guide to so many hikers.

For a total of fourteen years, until her death, Heiji continued to guide hikers though the Aso-Kuji area. And it was only after she had died that people became aware of a remarkable fact. During all the years of her term, there had not been one accident involving loss of life or limb, even though this mountain range had previously been notorious for its frequent disasters.

Every country has its share of dramatic dog rescue stories, in which dogs risk their lives and save great numbers of people. Though Heiji's story may be relatively unglamorous, she is surely extraordinary for having prevented even a single incident that could have led to injury or death. The figure of Heiji continuing to live her life proudly and independently deep in the mountains captures the courage and strength of purpose that is so typical of the Akita inu.

Local and national newspapers alike featured stories about Heiji's retirement.

Hiroko Sakai wrote a children's book about Heiji, which was published by Kaiseisha in 1989.

HACHIKO: The Akita Who Became a Symbol of Loyalty

One tale about a dog known by virtually everyone in Japan is that of Hachiko, an Akita inu. This true story is the most famous of all dog stories and has become a kind of modern legend, relayed from one generation to another and also finding its way into books, movies, and television dramas. Not only does it demonstrate the deep bond that can be formed between humans and dogs, it shows the essence of the temperament of a Japanese dog: loyalty and devotion. The legend of Hachi continues to tug at the heartstrings of Japanese people even today.

The events began roughly eighty years ago, in the early 1920s, when a certain Eisaburo Ueno, professor at the Department of Agriculture at the Imperial University (now the University of Tokyo) and resident of Shibuya, west central Tokyo, became the owner of an Akita inu puppy. The puppy came from Odate in Akita Prefecture, which was well known for producing fine Akita dogs. Born in late November (the exact date is unclear) in 1923, the puppy was delivered to Professor Ueno on January 10 the following year.

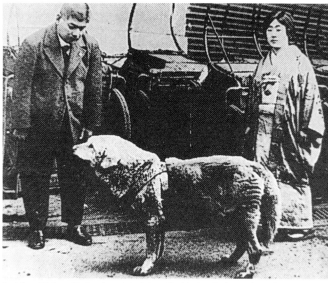

Hachiko at Shibuya Station, in a photo taken after his story had started to gain media attention.

Professor Ueno, who had always been a keen dog lover, named him Hachi and lavished him with love and affection. The puppy grew up to become a fine Akita inu, 64 centimeters (about 25 inches) tall, weighing 41 kilograms (90 pounds), with a sickle tail that curled to the left and a fine coat of light yellow fur.

Hachiko took to Professor Ueno extremely well, and when the professor set off to Shibuya Station in the mornings, usually at around nine A.M., either to go to the Department of Agriculture at the Imperial University or the Ministry of Agriculture and Forestry's laboratory in Nishigahara, Hachiko always went with him. After seeing his master off at the station, Hachiko would return home, and then in the evening at about six P.M. he would again set off to Shibuya Station and wait by the ticket gate for his master to appear. This became Hachiko's daily routine. The sight of the two of them setting out for the station in the morning and coming home together at night made a deep impression on all the passersby.

However, Hachiko's happy life as the pet of Professor Ueno was cut short by a very sad event, just one year and four months later. On May 21, 1925, Professor Ueno suffered a sudden stroke during a faculty meeting and died. The story goes that on the night of the wake, Hachiko, who was in the garden, broke through the glass doors into the house and made his way into the parlor where the body was laid out, and spent the night lying close beside his master, refusing to budge. Another account tells how, when the time came to put various objects particularly loved by the deceased in the coffin with the body, Hachiko jumped inside the coffin and tried to resist all attempts at removing him.

But it is after this that the really sad part of the story begins. After his master died, Hachiko was sent to live with relatives of Professor Ueno's who lived in Asakusa, in the eastern part of Tokyo. But he ran away repeatedly and returned to the house in Shibuya, and when a year had passed and he still hadn't taken to his new home, he was given to Professor Ueno's former gardener, who had known him since he was a puppy. But Hachiko ran away from this home repeatedly too. On realizing that his erstwhile master no longer lived in the old home in Shibuya, Hachiko went every day to Shibuya Station in the same way as he always had, and waited for him to come home. Every day he would go and look for the figure of Professor Ueno among the returning commuters, leaving only when pangs of hunger forced him to. And he did this day after day, year in and year out.

Hachiko eventually started to be noticed by people as he turned up every day at Shibuya Station. But what made him especially well known was a story that someone sent in to the *Asahi Shinbun*, one of the country's major newspapers, which was published in September 1932. The writer had been interested in Hachiko for some time, and had already sent photographs and details about him to a journal that specialized in Japanese dogs. A photo of Hachiko had also appeared in an encyclopedia on dogs published abroad. However, when a major national newspaper took up Hachiko's story, the entire Japanese populace got to know about him, after which Hachiko became something of a celebrity. He was invited several times to make a guest appearance in Nippo dog shows, and figurines and picture postcards started to be made of him.

On April 21, 1934, a bronze statue of Hachiko by the sculptor Teru Ando was erected in front of the ticket gate of Shibuya Station, with a poem engraved on a placard titled "Lines to a Loyal Dog." The unveiling ceremony was a grand occasion, with the grandchild of Professor Ueno in attendance and throngs of people who caused quite a delay in the proceedings. Regrettably, this first statue was removed and melted down for weaponry during World War II, in April 1944. However, in 1948 a replica was made by Takeshi Ando, son of the original sculptor, and reinstated in a ceremony on August 15. This is the statue that still stands today at Shibuya Station and is an extremely famous and popular rendezvous spot.

Hachiko's sudden fame made little difference to his life, however, which continued in exactly the same way as before. Every day he set out for Shibuya Station and waited there for Professor Ueno to come home. In 1929 Hachiko contracted a severe case of mange, which nearly killed him. Due to his years spent on the streets, he was thin and battle-scarred from fights with other dogs. One of his ears no longer stood up straight, and he was altogether a wretched figure, nothing like the proud, strong creature he had once been. He could have been mistaken for any old mongrel.

As Hachiko grew old, he became very weak and suffered badly from heartworms. Eventually, at the age of thirteen, in the early hours of March 8, 1935, he breathed his last in a Shibuya side street. The total length of time he had waited, pining for his master, was nine years and ten months. Hachiko's death made the front pages of major Japanese newspapers, and many people were heartbroken at the news. His bones were buried in a corner of Professor Ueno's burial plot, so he was finally reunited with the master for whom he had pined for so many years. His coat was preserved, and a stuffed figure of Hachiko can still been seen in the National Science Museum at Ueno.

The story of Hachiko has become etched in Japanese people's hearts, and it is certainly a most touching tale of the strong bond between a dog and his master and the boundless devotion of which Akita are capable.

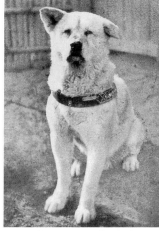

Years on the street eventually took their toll, leaving Hachiko scarred and sick.

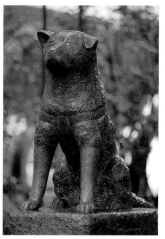

The bronze statue of Hachiko that stands outside Shibuya Station.

Appendices

■ THE BODY OF THE JAPANESE DOG

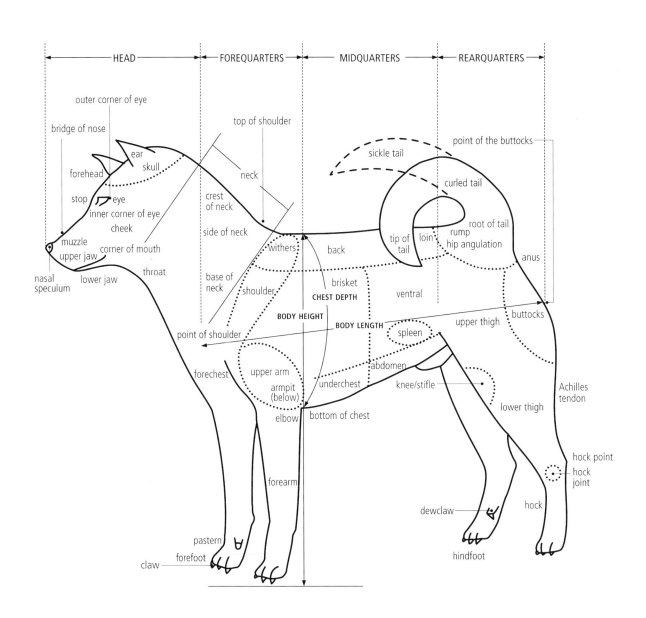

■ BONE STRUCTURE

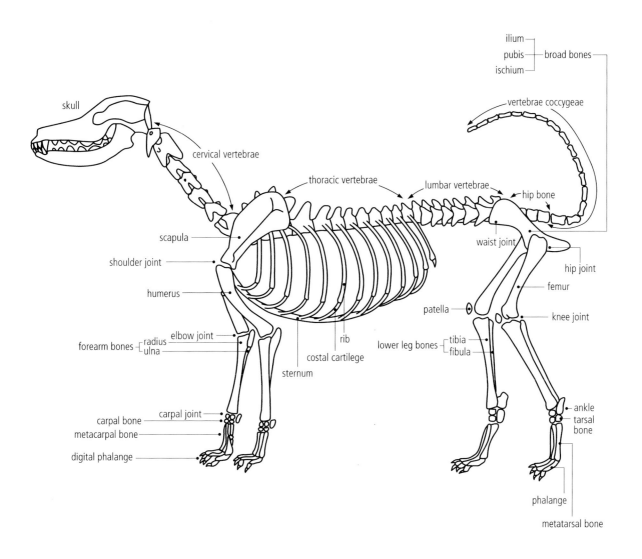

skull

ilium ┐
pubis ┤── broad bones
ischium ┘

vertebrae coccygeae

cervical vertebrae

thoracic vertebrae

lumbar vertebrae

hip bone

scapula

waist joint

shoulder joint

hip joint

humerus

femur

patella

knee joint

forearm bones ┌ radius
 └ ulna

elbow joint

rib

lower leg bones ┌ tibia
 └ fibula

costal cartilege

sternum

carpal joint

carpal bone

metacarpal bone

digital phalange

ankle
tarsal
bone

phalange

metatarsal bone

■ HEAD

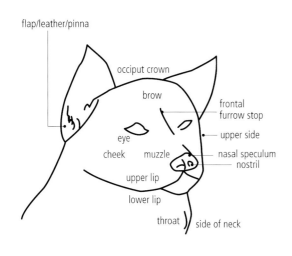

flap/leather/pinna

occiput crown

brow

frontal
furrow stop

upper side

eye

cheek muzzle

nasal speculum
nostril

upper lip

lower lip

throat side of neck

■ TEETH

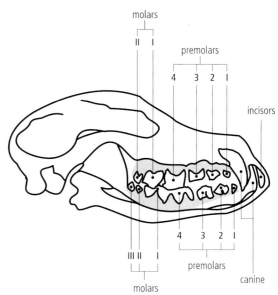

molars

II I

premolars

4 3 2 I

incisors

4 3 2 I

III II I

premolars

canine

molars

■ TERMS RELATED TO THE PAWS

FOREPAW

HIND PAW

carpal pad

first digit

metacarpal
pad

metatarsal
pad
(footpad)

digital pad

digital pad
(toe pad)

■ JOINT ANGLES

FOREARM JOINT ANGLES

1. scapula
2. humerus
3. forearm
4. metacarpal bone
5. digital phalange

REAR LEG JOINT ANGLES

1. lumbar vertebrae
2. broad bone
3. ischium
4. femur
5. lower leg bone
6. metatarsal
7. phalange

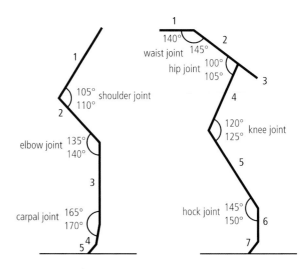

1
140°
waist joint 145°
hip joint 100°
105°

2

1

105° shoulder joint
110°

2

3

4

elbow joint 135°
140°

3

120° knee joint
125°

5

carpal joint 165°
170°

hock joint 145°
150° 6

5 4
5

7

■ TAIL

VARIETIES OF SICKLE TAIL VARIETIES OF CURLED TAIL

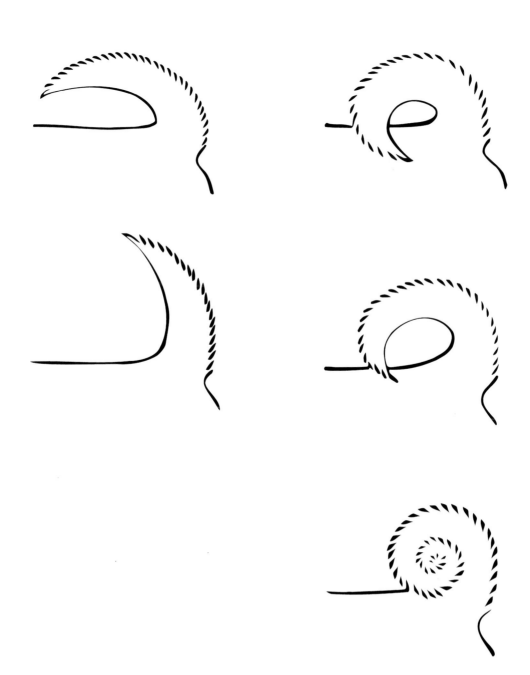

List of Authors

This book was a group effort. The following is a list of the authors, and of the sections of the book that they contributed. Michiko Chiba wishes to express her gratitude to all the coauthors who helped make this book possible.

MICHIKO CHIBA

Jomon Shiba: A Dog from Paleolithic Times Recreated by Contemporary Breeders (pp. 72–73)

Tama: A Shiba Who Rescued His Master from Being Buried in the Snow (pp. 82–83)

Heiji: The Akita Guide of Mountain Climbers (pp. 84–85)

YUICHI TANABE

The Paleolithic Dog as Companion (p. 62–63)

Changing Attitudes (pp. 63–64)

The Start of Preservation Movements and Breed Standardization (p. 65–66)

Genetic Evidence for the Routes Dogs Took to Japan (pp. 66–69)

TAKASHI TOJO

Akita (pp. 41–43)

Shiba (pp. 44–46)

TSUTOMU MURAOKA

Introduction (pp. 6–8)

Kishu (p. 47)

Shikoku (p. 48)

Kai (p. 49)

Hokkaido (p. 50)

Japanese Spitz (p. 51)

Chin (p. 52)

Japanese Terrier (p. 53)

Tosa Fighting Dog (p. 54)

Nippo (pp. 59–61)

The Ryukyu Dog of Okinawa (pp. 70–71)

Hunting and Japanese Dogs (pp. 74–81)

Hachiko: The Akita Who Became a Symbol of Loyalty (pp. 86–87)

Acknowledgments

The publisher wishes to express its gratitude to the following people and institutions who kindly granted permission to reproduce photographic images and drawings in this volume:

Akita Inu Preservation Society, Chuken Hachiko Bronze Statue Preservation Society, and Susumu Matsumura : 87 (right).

All Japan Hunting Club: 77

Collection of Hachiko-related documents edited by Masaharu Hayashi: 86; 87 (left).

Funabashi-shi Tobinodai Shiseki Koen Museum: 62

Gunma Prefectural Board of Education: 75

Kaiseisha: 84-85

Kimura, Masao: 79, 81

Koyasan Kongobuji Temple: 64 (left)

Kozanji: 63

Manno Art Museum: 65 (right)

Muramatsu Town Hall: 82 (above); 83 (above).

Nippo (Nihonken Hozonkai): 88-90

Osaka Center for Cultural Heritage: 64 (right)

Ryukyu Inu Preservation Society: 66

Shibaho: 72 (center and right); 73

Tanabe, Yuichi: 67

Tokyo National Museum: 50 (bottom); 65 (left [above, below] and center).

Photo Credits

Hiraiwa, Nobuyuki: 9-11; 13-40; 41; 42; 44; 45; 47; 48; 49; 50; 52; 53; 54; 56-58; 60-61; 68 (left [above]); 72 (far left); 78.

Iwago, Mitsuaki: 73 (right [above]).

Kuroi, Maki: 72 (center [above and below] and right [above and below]).

Tanabe, Yuichi: 68 (left [below] and right [above and below]; 69 (right); 70-71.

Additional Photos Courtesy of

Ariizumi, Kenji; Imai, Mika; Ishii, Katsumi; Ishii, Noboru; Iwahori, Yoshitaka; Iwahori, Yukio; Kawashima, Masami; Matsunaga, Juichi; Matsunoo, Yukako; Shibai, Yuji; Shirai, Koji; Suzuki, Hisao; Suzuki, Shizuo; Takai, Kinji; Tojo, Takashi; Totsuka, Hideo; and Yokota, Takao

Index

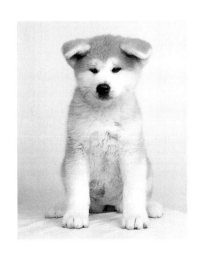

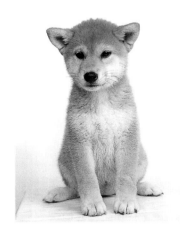

日本の犬
Japanese Dogs

2003年 5月 23日　第 1 刷発行

著　者　　千葉路子、田名部雄一、東條 隆、村岡 勤
発行者　　畑野文夫
発行所　　講談社インターナショナル株式会社
　　　　　〒112-8652 東京都文京区音羽 1-17-14
　　　　　電話　03-3944-6493 (編集部)
　　　　　　　　03-3944-6492 (営業部・業務部)
　　　　　ホームページ　www.kodansha-intl.co.jp

印刷所　　大日本印刷株式会社
製本所　　大日本印刷株式会社

落丁本・乱丁本は購入書店名を明記のうえ、小社業務部宛にお送り
ください。送料小社負担にてお取替えします。なお、この本につい
てのお問い合わせは、編集部宛にお願いいたします。本書の無断複
写 (コピー)、転載は著作権法の例外を除き、禁じられています。

定価はカバーに表示してあります。

© 千葉路子、田名部雄一、東條 隆、村岡 勤 2003
Printed in Japan
ISBN 4-7700-2875-X

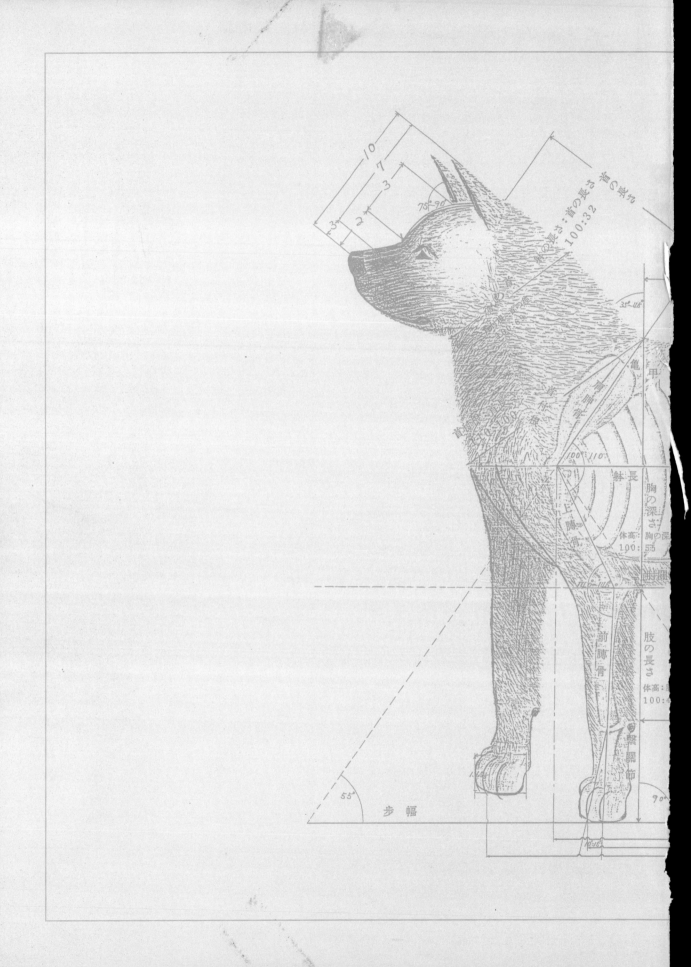